W9-BFQ-781

FUN WITH CLAY • FUN WITH BOXES • FUN WITH WOOD • FUN WITH PAPER

FUN WITH CLAY

FUN WITH CLAY

A book for all beginners, giving methods, full directions, and designs for all types of modeling with both self-hardening and kiln-baked clays.

By Joseph Leeming

Drawings by Jessie Robinson

SPENCER PRESS, INC., CHICAGO

Printed in the United States of America

Foreword

This book is intended primarily for beginners. For this reason it emphasizes the use of materials and methods that will produce finished pieces of pottery ware with the minimum of equipment. In this way, it differs considerably from most other books on the subject of pottery, which, for the most part, concentrate chiefly on descriptions of the more advanced and difficult methods that are used by commercial potters and craftsmen who have had long experience.

Pottery making today is a craft that anyone can learn and enjoy, for expensive kilns for firing the finished ware are no longer needed. This is because new types of clay have been developed that harden without firing or that can be fired and glazed in an ordinary kitchen oven.

The availability of these new clays makes it possible for the beginner to start with nothing but a few pounds of clay and some paints and glazes—all readily obtainable from any pottery supply dealer—and make scores of fascinating pottery pieces. One does not need a potter's wheel. The other methods of making pottery that are described in this book have been used by craftsmen for hundreds of years and produce beautiful finished pieces.

To many beginners it will be a surprise that by the simple but time-tried methods described in this book they can quickly make vases, ash trays, bowls, candlesticks and other pieces of pottery ware that are as finished and attractive in appearance as those seen in stores, museums or in one's own home. In short, the making of pottery is by no means as difficult as many people suppose. A little practice goes a long way, and it is a safe prediction that *you* will be surprised at the results you will be able to achieve after you have worked with clay for a short time.

Pottery making may be considered as a hobby or developed into an art as capable of giving deep and lasting satisfaction and of producing objects of lasting worth and beauty as painting, sculpture or any of the other arts. It is an age-old craft, probably one of the very first to be developed by primitive man. Basket weaving came before pottery mak-

ing and it is conjectured that clay was first used to make baskets watertight. Later, baskets were used as molds in which to press clay, and many early pieces of pottery ware show the impression of a basket on their surfaces.

Long before the Christian era, pottery making had become highly perfected in Egypt, Mesopotamia, Persia and China, the designs and decorations of these early potters surpassing much of the work of the present day. From these countries, skill in pottery making spread to Greece and the other Mediterranean countries in the West, and to Japan and India in the East.

In more modern times, potters in the United States and all the leading European countries have produced beautiful pieces possessing an infinite variety of form and decoration. The pottery of Limoges and Sevres in France, of Copenhagen in Denmark, and the ware produced by Josiah Spode and Josiah Wedgwood in England are world famous, while many lesser known potteries have contributed to the advance of the art and the production of pottery ware of outstanding excellence and beauty.

Some books about pottery which I have found valuable and which I would like to recommend to any readers interested in further study are: *The Art of Pottery* by I. M. Gall and V. M. Van Etta; *History of Pottery and Porcelain* by Joseph Marryat; *Potters, Their Arts and Crafts* by John C. Sparks and Walter Grandy; *The Potter's Craft* by Charles F. Binns; *Pottery: Finger-Built Methods* by Henry and Denise Wren; *Pottery for Artists, Craftsmen and Teachers* by George J. Cox; *Pottery Made Easy* by John W. Dougherty; *The Sculptor's Way, A Guide to Modeling and Sculpture* by Brenda Putnam.

Try your hand at pottery work, and it is almost a certainty that you will discover a hobby that will give you many hours of creative pleasure.

Joseph Leeming

Contents

1

Materials, Tools and Methods

There are very few things that you will need in order to have "fun with clay," and to make a practically endless variety of fascinating and beautiful articles of clay. All the materials, moreover, are inexpensive, with the exception of a regulation potter's wheel and a kiln for firing, but as you will soon see, you can get along perfectly well without either of these pieces of equipment.

This is (1) because practically every type of pottery can be made without the use of a potter's wheel and (2) because new types of clay have been perfected in recent years which harden and form finished pieces of pottery ware without being fired in a kiln.

Thus, pottery making which, until a few years ago required expensive equipment and considerable skill, is now an easy-to-learn craft within the reach of everyone. With the new clays that are now available you can make vases, bowls, tiles, ash trays, bookends, flower holders, candlesticks, human and animal figures, and many other articles that are just as attractive, colorful and decorative as those made with the regular pottery clays that must be hardened or matured by firing in a kiln.

How to "throw" pottery on a potter's wheel and how to operate a kiln are described in the last chapters of this book, and no doubt many who begin to work with clay will sooner or later want to have these pieces of equipment. To beginners at clay craft, however, it is recommended that they start by using the other time-tried methods of making "pots," as all types of vases are known, and other articles of clay, and that they use the newer types of clay that turn into beautifully finished pieces of pottery ware without the use of a kiln.

No specially-equipped work bench or table is needed for pottery work. An old wooden kitchen table or a smaller sized table purchased at a second-hand store is perfectly adequate. Two wooden uprights about 8-inches high can be nailed to one side of the table about three feet apart with a piece of copper wire stretched tightly between them. This is used in connection with "wedging" clay, explained later in this chapter.

11

WORK BATS

As a rule, you will not want to put the clay you are working with directly on the table, since clay sticks to wood. A usual practice is to cover the top of the work table with linoleum or oilcloth. This makes it easy to scrape off bits of clay. Then, in addition to this, you should use a separate, movable base or "bat" on which to build each piece you make. This may be a piece of strong cardboard or wood or a piece of pressed wood. Another convenient base is a circular piece of plaster, which is usually made by pouring the excess plaster used when making a plaster of paris mold, into an ordinary pie plate. How this is done is described in Chapter 6.

At the beginning, you will probably not be making plaster molds, and will therefore use one of the other kinds of bases or bats mentioned above. The principal reason for using a bat is so that the vase, figure or other object that you are making can be continually turned around as you work at it. This is necessary to allow you to mold and shape the piece without constantly moving about yourself, and it enables you to avoid building a lopsided piece.

The other equipment that you will need includes some tin cans or old pails in which to mix clay, cardboard for making templates, a sponge for smoothing the surface of finished pieces while the clay is still damp, some fine sandpaper for smoothing when the clay is hard, a knife, and possibly one or two modeling tools.

The first step in working with clay is, of course, to get some clay of the kind you want to use, so we will begin by describing the principal different kinds of clay. These may be obtained from a pottery supply dealer in your own city or from the dealers whose names are given in the back of this book.

THE DIFFERENT KINDS OF CLAY

Clay can be found in river banks and other localities in many parts of our country, but it is not all suitable for making pottery ware. This is because clay must have three properties to make it suitable for such use. It must be easy to mold or model; it must be porous enough to permit water to escape from it easily; and it must become properly hard

either by its own nature or by being fired in a kiln. Some of the clay that you might find near your home could have one or two of these characteristics, but would very seldom possess all three.

Because of these facts, clay craftsmen get their clay from the companies who have specialized in this business for many years. Some of the principal concerns of this kind are listed in the back of this book. If there is no pottery supply dealer in your town or city, write several of these companies and ask for their descriptive literature and catalogs. Once you have this material, you can order a few pounds of clay and start right in.

CLAYS THAT HARDEN WITHOUT FIRING

As has already been pointed out, there are several special clays available that harden without being fired in a kiln. Marblex and Model Light are plastic clays that come ready for use, while Mexican Pottery Clay comes in dry powder form and is mixed with water, as needed. Marblex is gray in color, Model Light is manufactured in gray, terra cotta and green, and Mexican Pottery Clay has a natural terra cotta color that is often left unpainted. Articles made with it resemble the Mexican and American Indian pottery made of native clays, with which many readers may be familiar.

Pottery made of Mexican Pottery Clay can be given greater strength and durability by baking it in a kitchen oven at 250°. After such a baking, the ware may be given a coating of a special Mexican Pottery Clay glaze, and rebaked at 150°. This gives a good long-lasting finish.

When Marblex, Model Light or Mexican Pottery Clay are not baked and glazed, but are decorated by means of painted designs, the pieces can be given a coat of clear varnish, which will help to insure greater permanency.

CLAYS THAT HARDEN IN A KITCHEN OVEN

These clays, of which several are available, are very useful. Articles made with them are thoroughly air dried and are then fired in a kitchen oven for fifteen minutes at 250 degrees Fahrenheit. These articles can be glazed with special glazes supplied by the companies that prepare the

clays, the glazes giving a glossy surface similar in appearance to glazes fired at high temperature in a kiln. Two of these special clays are known as Seramo and K.O. (Kitchen Oven) Modeling Clay.

The use of a glaze, it should be explained, protects the surface of the ware and makes it water-resistant. A glaze also provides an excellent base for colored designs applied by oil color, enamel paint, water colors or others special coloring mediums that are offered by pottery supply dealers. After the design or decoration has been painted on, the piece can be given a final coat or two of one of the special glazes, which will give a high finish and make the work fire- and water-resistant.

CLAYS THAT MUST BE HARDENED BY FIRING

These are the regular pottery clays, of which a great many different kinds are offered by the pottery supply dealers. Most clays require a certain amount of processing, refining and blending to make them suitable for pottery, and the concerns that deal in clay carry out these processes. As a result they can supply smooth textured, thoroughly mixed clays that are free from dirt or grit, and that possess the plastic and other properties needed to make good pottery ware. A typical mixed clay for making white pottery ware contains ball clay, China clay, feldspar and flint.

Clays come in different colors, chiefly white, gray, buff and red, these being the colors that are developed in them after they have been fired.

Pottery ware made of the regular pottery clays is usually decorated by being given an all-over coat of glossy colored glaze or is given a painted design which is covered by a coat of clear, transparent glaze.

CLAY CONSISTENCIES

There are a few terms, peculiar to the potter, that should be known by everyone who works with clay. They describe the different consistencies of clay.

Clay is said to be *wet* when it is the right consistency for throwing on the wheel or for making hand-drawn pottery. (See Section on "Types of Pottery Work".) In this condition it should be of a putty-like consistency and should not adhere to the fingers or crack when molded. Clay used for throwing should be slightly softer than that used

for hand-drawn or coiled pottery. Clay for making slab pottery should be rather stiffer.

Clay is said to be *moist hard* when there is no moisture on its surface. Handles, spouts and slip decorations are added to vases, jugs and other articles when the clay is of this consistency.

Clay is said to be *leather hard* when a certain amount of moisture has evaporated from it, so that it is lighter in color and, when the edges are scratched, the small pieces curl slightly.

When clay has dried out still more, it is said to be *white hard*. In this condition it is in the proper state for firing. When white hard clay is scratched or rubbed lightly, surface particles come off in the form of a fine powder.

Another term that you should know is *slip*. Slip is liquid clay of about the consistency of cream, and is used when attaching handles and spouts or making any joining. It is also mixed with colors and used for decorating pottery, this being known as slip painting or engobe painting.

HOW TO WEDGE CLAY

Clay that is to be used for making pottery must be wedged, this being the process used by potters to remove air bubbles and make the clay of the same consistency throughout. It should be emphasized right at the beginning that thorough wedging is of extreme importance when you are using clay that is to be hardened by firing. If air holes are not removed from this type of clay, they may cause quite serious explosions during the firing process. Every experienced potter knows this and realizes that the basic rule is, "Never skimp on wedging when using clays that are to be fired.

If you are using a self-hardening clay that does not have to be fired, wedging is not of such importance, for there is no danger of explosions during firing. With these clays wedging is used to make the clay plastic and workable.

To wedge clay, take an amount sufficient for the object you are going to make and form it into a rough ball shape. The clay should be quite moist, about the consistency of putty.

You must have ready a piece of thin wire stretched very tightly between two uprights. Usually the wire is fastened between two uprights

that hold it about 8 to 10 inches above a work table. Hold the ball of clay in both hands and push it down over the wire, cutting it into two parts.

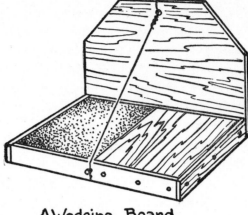

A Wedging Board

Instead of using a wire stretched between two vertical uprights, you can use a "wedging board," of the kind illustrated above. These are very convenient and have the advantage of taking up only a small amount of space. You can make one at home without difficulty or buy one from a pottery supply dealer.

The bottom of the board consists of a shallow wooden box with an inside measurement of 22 inches by 14 inches. The bottom of the box is made of a piece of ¼-inch thick wood measuring 22 inches by 14 inches, and the sides are fastened around this piece, not on top of it. The front side and the ends of the box are made of ½-inch thick wood and are 1 inch high. The rear side of the box is formed by a piece of ½-inch wood cut to the size and shape shown in the drawing. A small hole is bored in this piece near the top. To provide the needed strength it is best to fasten the corners of the box with screws rather than nails.

When the box has been completed, get a piece of hard wood that measures 11 inches by 14 inches and is ¾-inch thick. Fit this piece into the right-hand side of the box and fasten it securely in place by screws driven through the sides of the box. Coat the surface of this piece of wood with water resistant paint, which can be obtained at a hardware or paint store.

Then mix some plaster of paris, as described in Chapter 6, and pour it into the left-hand side of the box. Smooth the upper surface so it is even and flush with the top of the sides of the box.

Pass a piece of strong copper wire through the hole in the back piece; bring its end over the top of the piece from back to front, and twist the end securely around the standing part of the wire. Then lead the wire to a screw driven into the front of the box and twist it around the screw. The wire must be fastened securely, since it will be used time and again for cutting the balls of clay that are being wedged.

When using this board for wedging, air bubbles are removed and the clay is made more plastic by cutting it on the wire many times and working it on the wood surface. If the clay is damp it is rolled on the plaster, which is absorbent and removes the excess moisture.

When ready to wedge a ball of clay, take one part in each hand, with the cut sides facing each other, and bring the hands quickly together. This will drive out some of the air bubbles but the process must be repeated a number of times. Keep on slicing the clay and banging the two parts forcibly together until the inside cut parts are smooth and without air holes. The process may have to be repeated as many as fifty times. Experienced potters usually consider that clay that is to be fired should be wedged for a minimum of fifteen minutes.

When a large ball of clay is to be wedged, it is thrown downward against the taut wire, as this force is necessary to enable the wire to make a clean cut. One half of the ball is then placed on the table, with the cut side uppermost, and the other half is thrown forcibly down on it.

HOW TO MAKE SLIP

To make slip, fill a mixing bowl partly full of water and then pour powdered clay into it until the water will not absorb any more. Stir the mixture thoroughly and then pass it through a fine sieve to eliminate lumps and large particles.

You can store your slip conveniently in a wide-necked glass or earthenware jar. The glass jars used for preserving fruits are usually easy to get and are good for the purpose. Slip should be kept under about ½-inch of water to retain its consistency.

HOW TO STORE CLAY

Clay should be stored in a non-corrosive container, covered with a damp cloth and kept in a cool place if possible. An earthenware crock is ideal, and can be purchased inexpensively at a department store or in many ten-cent stores. You can also use one of the cylindrical tin boxes that some kinds of crackers come in, if you give it a coat or two of varnish inside to prevent rust.

Dealers in clay offer earthenware crocks in their catalogs, and also special wooden containers lined with galvanized tin. The latter usually cost from fifteen to twenty dollars, however, so you would be better advised at the beginning to get an inexpensive crock or use a varnished cracker tin.

Small quantities of clay may be wrapped in a damp cloth and then in oilcloth and stored in a wooden box.

CHECKING OR SMALL CUTTING

Checking or small cutting is employed to make a better join between two pieces of clay. It consists of making blunt indentations with a modeling tool, a nail or pointed stick in order to roughen the surface of the clay. If you are going to fasten a handle to a jug, for example, you should scratch the places on the jug where the ends of the handle are to go, so as to roughen the surface. The roughened spots are then coated with clay slip before the handle is put in place. Checking is also used when joining a clay coil to the base of a clay pot. The edge of the base is roughened and coated with slip before the coil is put in place. This makes the two pieces of clay adhere to each other more firmly.

HOW HANDLES AND SPOUTS ARE MADE

A description of how handles and other appendages are made and fastened in position is given in this chapter on "Material and Methods" because the processes apply to most of the kinds of pottery ware described in later chapters. In other words, it is one of the basic methods employed in connection with pottery ware.

Handles and other appendages are added when the clay of the body of the pot has hardened to the point where you can handle it without making finger prints on it. Handles are added to many pieces of pottery ware such as vases, pitchers, jugs, cups and candlesticks either for utility or for ornamentation. If you study pottery either in illustrated books devoted to the subject or by going to a museum, a commercial pottery or a store dealing in pottery, you will find great variety in handles. Some are round, some twisted, some flat. Some are modeled closely to the piece, while others continue a contour of the pot and so improve its over-all design.

There are two kinds of handles—rolled and pulled. The latter are the strongest and best.

To make a rolled handle, roll out a coil or rope of clay and place it on a piece of paper on which you have made a full-sized drawing of the finished handle. The clay should be soft enough so that it will not crack or break when it is bent. Curve the coil of clay to the shape of the drawing and cut off the extra clay at each end with a knife. Let the clay dry until it is stiff and then attach it to the pot.

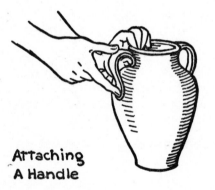

Attaching
A Handle

When ready to attach a handle, scratch the pot with a modeling tool or knife at the points where the top and bottom of the handle are to go. This is to roughen the clay so the handle will adhere better. (See "Checking or small cutting.") Cover the two points with thick clay slip and put the handle in place with your right hand. Put your left hand inside the pot and press outward against the two points to keep the pot from being pressed out of shape. When the handle is in place, smooth the places where it joins the pot with your fingers or a modeling tool.

Pulled handles, which are the strongest and best, are the kind that were used by the old peasant potters of England and other European countries. The first step in making one is to roll a lump or ball of clay into the shape of a cone. Hold the cone in your left hand with the pointed end down and slowly pull the clay out into a flat or rounded strip with your right hand. It is important to pull the clay with a *stroking* motion.

When the strip is a little longer than the intended handle, break it off from the rest of the clay. Bend the clay strip to the right shape by placing it on a full-scale drawing of the handle and then fasten it in place in the way just described.

Small spouts do not have to be attached, but are made by simply bending out the rim of the jug or pitcher while the clay is still soft and pliable.

Attaching a V or U Spout

Larger spouts are made separately from thin slabs of clay. It is a good plan to make a paper pattern of a large spout and to use it as a guide when cutting the clay spout from the clay slab. A V-shaped notch must be cut in the side of the jug or pitcher at the point where the spout is to be attached. Cut this with a knife just before you are ready to make and attach the spout. Cover the edges of the spout that are to fit against the pot with thick clay slip and put the spout in position. Press it firmly in place with the right hand, at the same time exerting counter pressure against the inner wall of the pot with the left hand.

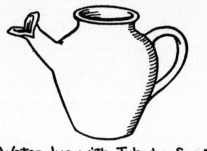

Water Jug with Tubular Spout

Tubular spouts are easily made from rolled out pieces of clay curved into the narrow cylindrical shape required. This is the simplest method and in many cases it provides a perfectly adequate spout. To get the clay into cylindrical shape it can be rolled around a finger, a pencil or a piece of dowel wood.

For fine pottery ware spouts are generally slip cast in plaster molds. (See Chapter 6 "Cast Pottery Ware.") A clay pattern of the spout is modeled, which is solid throughout. When the clay has dried and become stiff, a two-piece plaster of paris mold is cast around this pattern and the spout is made by slip casting, that is, pouring clay slip into the mold.

Whichever type of spout is used, it is attached to the body of the piece being made in the same manner as handles are attached.

HOW POTTERY IS DECORATED

The seven most commonly used methods of decorating pottery ware are (1) Incising, (2) Relief, (3) Sgraffito or Scratched Decoration, (4) Slip or Engobe Painting, (5) Simple Glazing, (6) Underglaze Painting, and (7) Overglaze Painting. (See page 22) Each of these is briefly described here and instructions for applying designs and decoration by each method are given in the chapter on "Decorating and Glazing Pottery Ware."

1. *Incising.* In this simple form of decoration, a design is cut or incised in the clay, when it is leather hard, with a pointed incising tool.

2. *Relief.* The design is raised by cutting away the clay surrounding it.

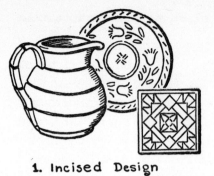

1. Incised Design

2. Relief Design

4. Scraffito or Scratched Decoration

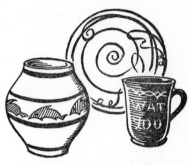

3. Slip Decoration

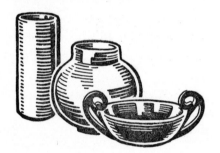

5. All-over Colored Glaze

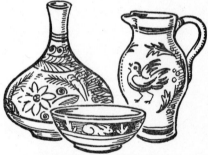

6. Underglaze Painting

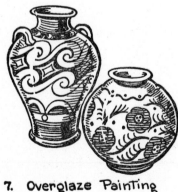

7. Overglaze Painting

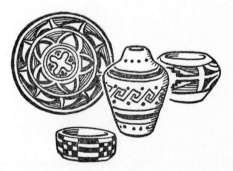

8. Pottery made of Self-hardening Clay with Painted Designs

3. *Sgraffito.* In sgraffito decoration, a vase or other object is covered with a coat of slip, which is of a contrasting color to the clay of which the object is made. A design is drawn on the slip and portions are then cut or scratched away to reveal the differently colored clay underneath.

4. *Slip or Engobe Painting.* This consists of painting on the design with a colored slip, or a mixture of clay and water. It is a very commonly used method when the pottery is made of a clay that must be hardened by firing. The word "engobe" means simply a thin layer of slip applied to the surface of a piece of pottery.

5. *Simple Glazing.* The pottery is given an all-over coating of clear or colored glaze, which is matured by firing.

6. *Underglaze Painting.* The design is painted on the ware with special underglaze colors after the first or biscuit firing. A coat of clear glaze is then applied and the piece is given a second or glost firing to develop the glaze.

7. *Overglaze Painting.* After a piece has been given a biscuit firing to harden the clay, a glaze is applied and matured by a second or glost firing. The design is then painted on over the glaze and the piece is given a third firing.

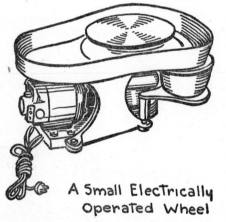

A Small Electrically Operated Wheel

THE POTTER'S WHEEL

There are several kinds of potters' wheels, and all of them are fairly expensive. For this reason, the best plan for the beginner is to make some of the numerous things that do not require a wheel, and then, if the pleasure of working with clay becomes a permanent hobby or if you wish to make pottery to sell, you can get a wheel at the proper time.

Actually, you can make every conceivable kind of pottery without a wheel, and many people who have enjoyed working with clay for years have never owned one. So, don't let the absence of a wheel keep you from starting right in and commencing to have "Fun with clay."

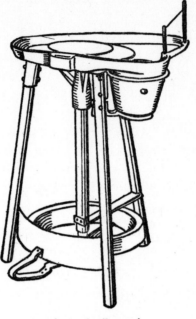

A Kick Wheel

A widely used type of wheel is the kick-wheel, which is shown above. The circular throwing head, on which the vase or other object is made, is made to revolve by a foot treadle. Simply constructed wheels of this kind can be bought from pottery supply dealers for about $40. The regular wheels usually cost about $100. A good electrically-driven potters' wheel costs about $100, and a more elaborate type about $200.

Detailed instructions for throwing pottery on a wheel are given in the Chapter "Throwing On The Potter's Wheel."

FIRING POTTERY

Pottery is ordinarily fired in two stages, known as biscuit and glaze or glost. The biscuit, or first firing, bakes the clay and makes it hard, while the second firing vitrifies or develops the glaze, which has been

put on not only to beautify the ware but also to make it perfectly smooth and waterproof, and to serve as a protective coating.

For firing, you will need a kiln. But as has already been pointed out, you can make very durable pottery of many kinds with the self-hardening clays, and you will not want or need a kiln unless you develop into a thorough-going potter.

Kilns may be electric or fired by gas or oil. The electric ones offer a number of advantages. They do not require chimney outlets, for example, and so can be set up and used in any room that has the proper electric connection. They are also considerably easier to operate than the other types.

Small electric kilns, having a firing chamber measuring 3½" x 3½" x 4" can be purchased for $17.50. A larger and more useful size, with a 5" x 5" x 5" firing chamber costs about $40.00. Prices then increase rapidly, a kiln with an 8" x 9" x 9" chamber costing $120.00, and one with a 10" x 12" x 12" chamber is $250.00.

Notes on the firing of pottery are given in the chapter dealing with that subject.

TYPES OF POTTERY WORK

Several methods are commonly used for making pottery ware such as bowls, jars, vases, pitchers and other objects, broadly described as "pots." This is a term that includes pottery receptacles of literally thousands of shapes and sizes. Indeed, in the world of the potters, practically any and every receptacle made of clay, whether cylindrical, rectangular or of some other simple or intricate design, is known as a "pot."

In addition to the making of pots, workers in clay also make decorative tiles and modeled figures, which may be of humans or animals or of fruits and other natural objects. Other pottery ware popular with beginners and experienced craftsmen alike, includes candlesticks, boxes and ash-trays. Examples of all these articles are illustrated in this book, together with directions for making them.

The methods used for making "pots," or the usual pottery ware such as vases and bowls, are briefly described below. Later chapters are devoted to each of these methods and the kinds of pots made by them.

1. *Coiled Pottery*. In this method the clay is first rolled into long cylindrical "ropes" or "coils" about ½-inch in diameter, or else is flat-

tened and cut into strips about 1 inch wide and ½-inch thick. The pot is then built up by placing the coils or strips one on top of the other, the desired shape of the finished pot being obtained by using a cardboard template as a guide.

2. *Hand-drawn Pottery*. In this method you start with a ball of clay and by manipulation with the thumbs inside and the fingers outside, gradually mold the ball to the shape of the finished pot. This method is essentially similar to the one used by the potter at his wheel. Although no wheel is used, the pot is turned continually during the shaping process.

3. *Slab Pots*. This method is used chiefly to make pots that are rectangular or of other geometrical design. The clay is rolled into flat slabs. These are then cut to the necessary sizes and shapes to build up the finished pot.

4. *Throwing on the Potter's Wheel*. When using a wheel, a lump or ball of clay is placed in the center of the throwing head or circular turn-table. Then, as the throwing head is made to revolve, the clay is molded into shape with the thumbs and fingers. It is not an easy matter for a beginner to get good results with a wheel, but once you get the knack of it, you can make bowls, plates, vases and other "pots" more quickly and with greater accuracy than by the hand-modeling methods.

A detailed description of how to use a potter's wheel is given in Chapter 7. It should be repeated, however, that you do not need a wheel in order to have countless hours of fun and enjoyment with clay.

5. *Tiles*. Decorative clay tiles are easy to make and have a number of uses, such as flower pot holders, paperweights, wall decorations, or to place under hot coffee or tea pots.

6. *Modeling*. Under this head comes the modeling of innumerable animal and human figures, statuettes, heads, and of any other natural objects such as fruits and flowers. Suggestions for a number of articles of this kind are illustrated in the chapter on "Modeling Clay Figures."

7. *Casting*. Casting is a separate branch of work, which is widely used for making pottery jars, vases and modeled figures. How to make cast pottery is described in the chapter on "Cast Pottery Ware."

2

How to Make Clay Tiles

If you are just beginning to work with clay, you will find it a good plan to make some clay tiles before commencing to make vases, ash trays, candlesticks or other types of pottery ware. This is both because tiles are very easy to make and because their construction does a great deal to familiarize beginners with the feel of clay and with the way of handling it.

Tiles can be made of any kind of clay, either the self-hardening types or the ordinary kind that is hardened by firing. They are usually decorated with simple but striking designs executed in bright contrasting colors.

METHODS OF DECORATING TILES

Tiles may be left with a flat surface and decorated by means of designs executed with paints or glazes. It is more usual, however, to bring out the design by using one of three methods of decoration (1) an incised design, (2) a design in relief or (3) an inlaid design.

An incised design is made by scratching or cutting the lines of the design in the tile with a sharp tool while the clay is in the leather-hard condition. Special incising tools for this purpose are sold by pottery supply dealers. The lines are usually made with a depth and breadth of $\frac{1}{16}$ inch to $\frac{1}{8}$ inch, but may be wider if the pattern requires it. When the design has been incised, the tile should be smoothed with a damp sponge and then be allowed to dry slowly. Color can be added either with paints or with glazes.

A relief design is one which is raised above the flat background of the tile. In this case the clay surrounding the design is cut away with a modeling tool. When a design in relief has been completed, all sharp edges should be rounded by delicately smoothing them with a dampened finger-tip if the tile is to be glazed. This will prevent the glaze from becoming too thin along the edges of the pattern.

27

Inlaid designs are made by removing sections of clay with a modeling tool from different parts of the design and then filling these depressions with clay of a different color. The work should be done as soon as the clay is hard enough to handle, and the cutout sections should be ¼ inch deep. When all the required parts of the design have been dug out or cut away, pieces of differently colored clay are cut to fit each depression. The depressions are then coated with clay slip and the colored pieces to be inlaid are pressed into place. After the clay has dried, the surface of the tile is rubbed with very fine sandpaper to remove unevenness.

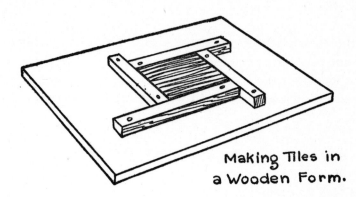

Making Tiles in a Wooden Form.

MAKING TILES IN WOODEN FORMS

In this method of tile making, a wooden form is used that has the dimensions desired for the finished tiles. One of the most easily made forms is the kind shown above. It is put together by nailing four strips of wood to a smooth piece of board. The strips should be 1 inch wide and their height may vary from ⅜ inch to ¾ inch, depending on how thick you wish the finished tiles to be.

It is a good plan to put a piece of oilcloth on the base board before nailing down the strips. This will keep the board from warping.

When the form is ready, roll out a slab of clay as described in Chapter 5 on "Slab Pots," making it about ⅛ inch thicker than the finished tile is to be. Frequently, to lessen shrinkage, the clay used for tiles is mixed with "grog," which is made from pieces of unglazed pottery pounded up into powder and screened through a fine sieve. If grog is used, it should constitute one-fourth of the mixture of clay and grog.

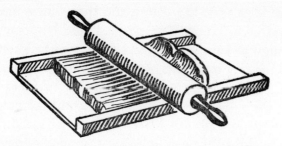

Board for Rolling Out Clay Slab

After the slab has been rolled out, give the wooden form a light coating of fine clay dust or French chalk to keep the clay from adhering to it. Then cut from the slab a piece that will fit comfortably into the form and roll it down with a rolling pin. Do not roll the pin all the way across the surface of the clay, but work from the center outwards to all four sides.

Surplus clay will be rolled out over the edges of the form and should be scraped off with a wooden stick or a knife. Keep rolling the clay until it is packed well down into a compact mass.

Let the tile dry until it is leather-hard; then separate it from the form by running a knife around its edges. Turn the form over and let the tile slip out, bottom up, onto your work table.

If the tile is to be decorated with an incised, relief or inlaid design, the work should be done at this point while the clay is still in a plastic state.

Clay tiles should be allowed to dry very slowly, and for this reason should be put in a cool place. If they dry too quickly under heat, they are apt to crack or warp. The edges have a tendency to dry more rapidly than the center and usually should be dampened from time to time to prevent this.

As has already been mentioned, tiles may be made either of self-hardening clay or the usual commercial types of clay that must be hardened by firing. The first kind of clay is simpler for most beginners to use and the designs on tiles made with it can be beautifully colored with the paints and lacquers sold by pottery supply dealers for this purpose. Tiles made with ordinary commercial clays are hardened by means of firing and are colored by means of underglaze colors and glazes.

Incised Designs for Tiles

Relief Designs for Tiles

Inlaid Designs for Tiles

3

Coiled Pottery

Because of its simplicity, the coil system of making pottery is an excellent one with which to start your first experiments. Either kind of clay may be used—the self-hardening type or the kind that is hardened by firing. Despite its simplicity, beautifully finished vases, bowls and other types of pottery can be made by this method. Several different kinds of coiled pots, showing what can be accomplished, are shown here.

WITH CYLINDRICAL COILS

The first step is to make a profile drawing of the vase, bowl or other object that you are going to make. You should make the drawing ten per cent larger than the finished pot is to be, to allow for shrinkage due to water evaporating from the clay when its dries out.

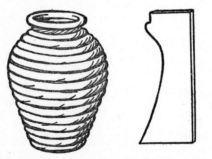

Coiled Vase and Cardboard Template
used as a guide in making iT.

Now make a cardboard template by tracing one side of the drawing on a piece of cardboard and cutting along the line showing the shape of the pot. This gives you a template of the same shape as the outside contour of the pot.

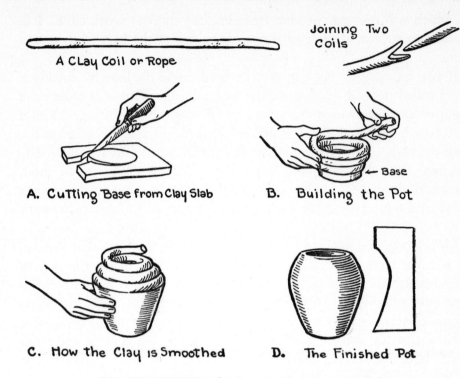

A Clay Coil or Rope

Joining Two Coils

A. Cutting Base from Clay Slab

B. Building the Pot

← Base

C. How the Clay is Smoothed

D. The Finished Pot

COILED POTTERY (Using Cylindrical Coils)

The pot is to be built up of coils or ropes of soft clay. To make the coils roll a slab of clay about ½-inch thick. Cut a ½-inch strip from this slab and roll it gently under your palms until it is a smooth coil. If clay that must be fired is being used, there must be no cracks in the coil, as these might form airholes in the finished pot. These could explode during firing, though thorough wedging will eliminate this possibility.

The right consistency for the clay is determined by the reaction of a coil when it is bent. If it cracks, it is too stiff and more water must be added. Coils generally range from ⅜-inch in diameter for small articles to 1-inch in diameter for the largest sizes. The best rule is to make each coil just before it is to be used. It is advisable to have a damp sponge on hand with which to moisten your fingers from time to time, as you make the coils and build the pot.

The first step is to make the base of the pot. This can be cut from a slab of clay, as shown at A, or can be shaped up into circular form of the right diameter by wrapping a coil around and around. It is a good idea to make the base on a piece of strong paper or a moistened plaster work

bat, which will prevent the clay from sticking to your work table. It is also well to cut out a circle of paper of the size of the base to serve as a guide.

If you are using a clay that is to be fired, make the base by cutting it from a rolled-out slab of thoroughly wedged clay. This will reduce the danger of air holes which might cause explosions during firing. With a coiled base it is very difficult to eliminate all the air spaces that form between the coils. This is of no great importance when you are using self-hardening clays, but it is very important when the clay is to be fired. You will find a pair of dividers very useful for marking out circular pieces of clay and most experienced potters keep a pair on or near their work table.

Making a coiled base is a little simpler if you taper the end of the coil that is to be in the middle. Draw the damp sponge along the coil to moisten it slightly and prevent its cracking. Then form the tapered end into a small circular mass and wrap the coil around and around it. Press the coils closely together so that no airholes will be left between them.

Now smooth out the clay by rubbing your fingers over the coils. Smooth both the top and bottom of the base in this way. Then trim the base into perfect circular form, using your paper guide and, if needed, a knife.

The next step is to build up the sides of the pot. You can do this (1) by using long coils wound upward in spiral formation or (2) by using shorter coils, each of which goes once around the pot.

The first method is the one most generally employed. Before putting the first coil in place, roughen the rim of the base by checking or small cutting, scratching shallow lines with a modeling tool or some other pointed instrument. Taper the end of the first coil and place it on top of the outside edge of the base. Then although this is not absolutely necessary, you can weld the coil to the base with some "slip" applied with a small brush.

When you have used up the first coil and start using a second one, join the two together by splitting the end of the one and tapering the end of the other. Then moisten the clay and model the two pieces together. (See illustration opposite.)

When the pot is about one-half built up, smooth the clay both inside and out by rubbing with your fingers. This is the usual procedure, but pots are sometimes left with the coils not rubbed smooth. You can, of course, make whichever kind you like, or both kinds. The illustration

C shows how the lower half of a pot is smoothed as the work progresses.

As you build up the sides of the pot, and later as you smooth the clay, use your template at each step to make sure that the pot is assuming the finished shape you have planned. This is done by holding the template against the sides, and widening or pressing in the coils, whichever may be needed.

If the pot is to curve in, carry the coil to the inside of the one below it. If it is to curve out, carry the coil to the outside of the preceding one. Work with your fingers on the inside and outside both, as you do the coiling.

When you come to the top, taper the end of the last coil. Then put a piece of cardboard over the top to see if it is level. If necessary, add or take off some clay where the top may be uneven.

The pot is completed by smoothing its upper half and trueing up the shape all round by the use of the template. (See D.) If there are irregular parts that need correction after the clay has dried, you can smooth them into shape with coarse sandpaper.

If you wish to make a lid, make it in the same way as the base, and add a knob of clay.

If self-hardening clay has been used, you can paint the finished pot with any design that is appropriate to its size and shape. If the pot is to be fired, it may be decorated with a design painted with underglaze colors or may be given an all-over coating of colored glaze.

POTTERY WITH FLAT STRIPS

Many people prefer to use flat strips of clay, rather than cylindrical coils, believing that a more perfect piece of pottery can be made in this way. Experience would tend to show, however, that the method used is largely a matter of personal preference.

The first step, when flat strips are to be used, is to roll the clay out in a slab about ½ inch thick. If a small pot is to be made, the slab should be thinner, about ⅜ inch.

Next cut a cardboard template of the side of the pot, and also a circular base pattern of the correct diameter.

Cut the base from the clay slab, using the base pattern as a guide. Then cut the remainder of the slab into strips about 1 inch wide.

In this method, strips are placed one on top of the other; that is,

COILED POTTERY
Using Flat Strips —

Flat Strip with Diagonal Ends

A— Fastening first strip to base with small role of clay

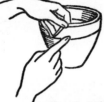

B— Adding a strip

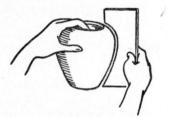

C— Trueing up the finished pot

D— The complete pot

several strips are used instead of one or two long ones that are coiled around to form several layers. Each strip should be cut with diagonal ends, which makes it easier to weld the ends together smoothly.

Start to build the pot by placing the first strip around the outside of the base, slanting it outwards to the degree required by the design. Check this by using the template. Then weld the strip to the base on the inside with a small roll of clay. (See A.)

Now add additional strips (B), using the template at each step (C). After each strip has been put in place, secure it and smooth over the join by rubbing inside and out with your fingers.

When the pot has been completed (D), let the clay become nearly dry and then true it into final shape by scraping it with the template. Soften the clay with a damp sponge where irregularities have to be removed. If a final finishing to shape and smoothness is required, you can use coarse sandpaper.

COILED POTS of VARIOUS DESIGNS

Unsmoothed Coils

Partially Smoothed Coils

Smoothed Coils

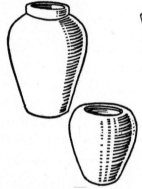
Flower Vases

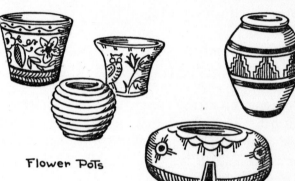
Flower Pots

Indian Type Pots

Hand Drawn and Hand Modeled Pottery

This is another very simple method of making pottery and one that is widely used by amateur craftsmen. It is suitable for making vases, bowls and ash trays of many different kinds.

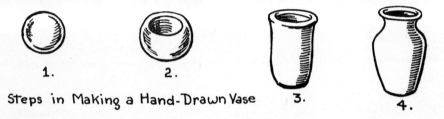

1. 2. 3. 4.

Steps in Making a Hand-Drawn Vase

START WITH A CLAY BALL

In using this method you start with a lump of clay about the size of a tennis ball. The clay should, as always, be well wedged or kneaded to get rid of air holes, and should then be shaped into as perfect a spherical shape as possible. It is a good idea to make a drawing of the pot you intend to make to serve as a guide.

When the ball is ready, put it on a small wooden board, a plaster work

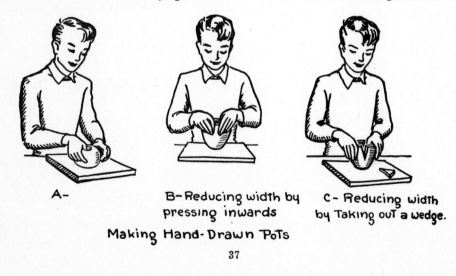

A-

B- Reducing width by pressing inwards

C- Reducing width by Taking out a wedge.

Making Hand-Drawn Pots

bat, or a piece of linoleum, cardboard or strong paper that you can turn around as you proceed with the work. Then moisten your right thumb in water, and press it into the center of the ball at the top (A). With the left hand turn around the board or paper on which the clay is resting, continuing to press down with the right thumb until the hole is large enough to hold both thumbs. Then put both thumbs in the hole and, with the fingers outside, begin to press the sides upwards and outwards, turning the pot as you work (B). Sometimes, particularly with small pieces, the pressing is done by the right hand only, while the left turns the pot around.

Continue working until the thickness of the sides is about ¼ inch and of uniform thickness at every point.

POINTS TO WATCH

Pay special attention to the following points:

1. The base where it joins the sides. There is a tendency to leave this part too thick.

2. The rim or top edge of the pot. This part tends to crack, even at the beginning of the work when the thumb is first inserted. If cracks start, smooth them over so as to keep a smooth even edge all the time.

3. Be careful not to make the top edge thinner than the rest of the pot. This is a common tendency. If you find the edge getting too thin, fold it inward and press it well into the sides.

You will find that the clay tends to spread outwards and must sometimes be pressed inward. This is easily done by putting both thumbs inside the pot, with the fingers outside, and then pressing inward with the fingers (B). Repeat this all around the pot and the diameter will decrease, while at the same time the height will increase. A definite narrowing at the top can be done by actually cutting out a wedge (C).

By using the thumbs and fingers in the same position and either pressing out or pressing in, you will find that you can mold almost any shape you wish.

When the pot is completed, finish it off neatly, making both the inside and the outside smooth. After the clay has dried, the pot can, of course, be decorated in any way that you wish.

INDIAN DESIGNS

The simple but graceful shapes of American Indian bowls and vases are particularly suitable for reproduction by the hand-drawn process, and a number of different examples are illustrated. Also shown are some of the Indians' decorative symbols that can be used for decoration. By using

INDIAN BOWLS and VASES that can easily be made by Hand

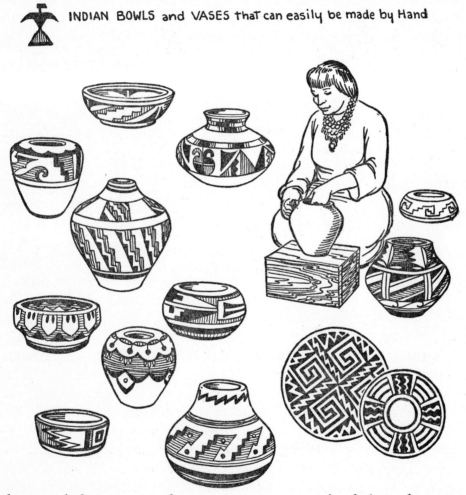

these symbols you can make up your own composite designs, the meaning of which will be decipherable by those who are familiar with the meanings of the different symbols.

Mexican Pottery Clay, which has a beautiful terra-cotta color, is very appropriate for Indian-type pottery, since much of the real Indian ware is made from similar clays. The warm reddish color provides a very

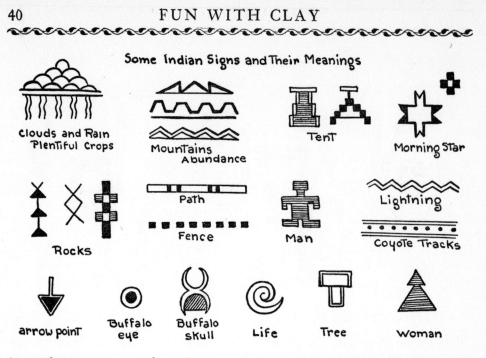

Some Indian Signs and Their Meanings

Clouds and Rain
Plentiful Crops

Mountains
Abundance

Tent

Morning Star

Rocks

Path

Fence

Man

Lightning

Coyote Tracks

arrow point

Buffalo
eye

Buffalo
skull

Life

Tree

Woman

beautiful background for whatever designs are painted on after the clay has dried. It is suggested that you use tempera paints, which are obtainable from pottery supply dealers, and that you give the ware a coating of clear varnish after the clay and the paints are thoroughly dry. The varnish provides an attractive finish and also gives greater permanency to the pieces.

MINIATURE VASES

Some beginners in the art of pottery have gotten a great deal of pleasure from making very small hand-drawn vases, measuring only two or three inches in height. These are easier to make than the larger vases, because there is less clay to manage and the small shapes are easier to control. The little vases can be turned out quite rapidly and, when painted or glazed with bright colors, are exceptionally attractive. Several appropriate shapes for these miniature pots are shown here. All are relatively simple shapes that are not at all difficult to make.

Several amateur potters known to the writer have been very successful in selling miniature vases of this nature through novelty and other retail stores in the towns in which they live. Part of their success has been due to the fact that they have put small sprigs of artificial flowers in the little pots, thus making a rather unique decorative piece, possessing more sales appeal than an empty vase.

Miniature Vases

If any reader should try out this idea and find an unexpectedly large demand for his or her product, as has happened more than once, it is recommended that the vases be made by slip casting them in two-piece plaster molds, as described in Chapter 6. By this method, dozens or even hundreds of the vases can be made in a relatively short period of time.

A SIMPLE WAY TO MAKE PLATES

The method of making plates described here is not exactly a hand-drawn process, but is sufficiently a hand method to justify inclusion in this chapter. Commercial potters and experienced craftsmen make plates by pressing slabs of clay in a hand mold, and this method is described in Chapter 6, dealing with cast and pressed pottery ware, which explains how to make pottery with the aid of plaster-of-paris molds.

The simplest method of making plates is to use a finished plate taken from your own pantry or china cupboard as a mold. This method gives good results and eliminates the necessity of making a special plaster-of-paris mold. You can use any of the three kinds of clay—the self-hardening, the type that is fired in a kitchen oven or regular pottery clay that is fired in a kiln.

Choose a plate of the size that you wish to duplicate. Then, after wedging the clay, roll out a slab of clay that is large enough to cover the plate and project beyond its rim at all points. The slab should have a thickness equal to that of the plate you are making.

When the clay is ready, put the plate on your work table and cover it with a square piece of white linen or cotton cloth. This will keep the clay from sticking to the plate. Then put the clay slab on top of the linen and press it down with your fingers to make it conform to the shape of the plate. The plate itself will serve as a one-piece mold and the clay will readily take its form.

The next step is to cut off the parts of the clay that project beyond the rim of the plate. Use a sharp knife and hold it vertically, straight up and down. Take your time and move the knife very slowly so as not to tear the clay or pull it out of shape. When the cutting is finished, smooth and round with your fingers the edges of the clay plate you have just made.

Put the plate away to dry and when the clay is hard enough, remove the cloth. Then cut from a thin slab of clay a narrow strip about ⅛ inch wide and long enough to form a circle in the center of the bottom of the plate. Join the two ends of the strip to make a circle, wet the top surface and press it into position on the bottom of the plate.

This circular ridge can also be made by modeling the bottom of the plate with your fingers. If you use this method, you must be careful not to press the plate out of shape while you are working on its under side.

When the plate is drying, the rim will tend to dry faster than the center. You should, therefore, run a wet brush around the edge every hour or so to retard the drying of the rim.

When the newly-made plate is thoroughly dry, smooth its surface with very fine sandpaper. You can then paint on colored designs of any kind you wish. A walk through the china department of a department store or even a ten-cent store will give you a number of suggestions and will show you the great variety of designs that are suitable for plates.

Some amateur potters have enjoyed making copies of the very gay and colorful plates that are made at Quimper in Brittany. These have bright floral and linear designs and sometimes human figures that are simple to draw and paint in blue, red and yellow. Many of the Italian plates are equally colorful and attractive and are excellent models for those who are just learning how to make pottery to copy.

There is no need, of course, to follow the designs on plates that you see in your home or elsewhere. A great part of the fun of pottery lies in creating your own designs.

If you use a terra-cotta colored clay, you will probably want to leave the clay its natural warm color. With whitish or gray clays, however, a frequent practice is to paint the entire plate to give it a glossier appearance

and a more attractive color. Use the so-called tempera colors that are sold by pottery supply dealers and artists' supply stores. A shade that is widely used for this purpose is a creamy white. This is made by mixing enough white paint to cover the plate and then adding a small amount of brown paint to give the creamy white shade. Colored designs can then be painted on over the creamy white surface and, when the paint has dried, the plate can be given a coat of clear varnish, such as Valspar.

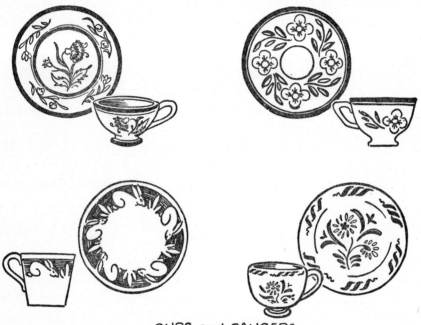

CUPS and SAUCERS

A SIMPLE WAY TO MAKE CUPS AND SAUCERS

Commercial potters make cups and saucers by using molds or throwing them on the wheel, but you can get very good results by using simple hand methods.

Saucers are made in exactly the same way as plates. Cover the saucer you are using as a model with a piece of linen or cotton cloth, and press a thin slab of clay down onto the cloth, smoothing it with your fingers until it takes the shape of the saucer.

Cups are best made by the hand-drawn method. Put the cup you are using as a model in front of you, and then make a ball of well-wedged clay

one-half as large as the cup. Smooth the surface of the ball and make a hole in it with one of your thumbs or forefingers. Gradually enlarge the hole, inserting your right thumb into it and then both thumbs, as described at the beginning of this chapter. Model the clay to give it the shape of the cup and, as a guide, use a cardboard template to help in getting the right shape.

Make a thin roll of clay for the cup's handle. When it is rolled to the right thickness and cut to the right length, dip it in water and then put it on the cup, pressing each end firmly into the clay surface of the cup.

Cups and saucers may be given floral or linear designs, but are very frequently decorated with a single all-over cover. If you are using regular pottery clay, this can be covered with a transparent glaze to produce a glossy appearance. Very nearly the same effect is obtained with self-hardening clays that need no firing, by painting with tempera colors and then finishing off with a coat of clear Valspar or other similar varnish.

Apple

Jack-O-Lantern

Mexican Hat Ash Tray

HAND-DRAWN NOVELTIES

HAND DRAWN NOVELTIES

Three attractive novelties made by the hand-drawn method are shown above. The apple and the Jack-o-Lantern are small jars provided with lids or covers, that can be used to hold candies or placed on a bureau or table to hold odds and ends. Both are modeled to shape as already described and, around the opening at the top, a narrow ledge is made to hold the lid. The lids are modeled from small pieces of rolled-out clay and a small piece of clay is attached to represent the stem. The eyes, nose and mouth of the Jack-o-Lantern are cut out with a knife as soon as the clay has hardened enough to make clean-cut knife strokes possible. When the clay has hardened, paint the pieces in their natural colors, the apple red and yellow and the pumpkin orange.

To make the Mexican sombrero ash tray, roll out a slab of clay about

⅛ inch thick and cut it with a knife into roughly circular form. Push up the center of the clay from beneath to form the crown, which is hollow underneath just like a regular hat. When the crown has been modeled to shape, curl up the clay around the edges of the brim and then let the clay harden before painting on the design. The best clay to use for the hat is Mexican pottery clay.

You will find it real fun to make and color the different buildings shown above, each of which, when completed, is a decorative and unique piece of pottery work. They will excite a good deal of attention wherever they are placed in your home, and they make out-of-the-ordinary Christmas presents. As with all pottery work, the use of bright colors adds tremendously to the effectiveness of the completed pieces.

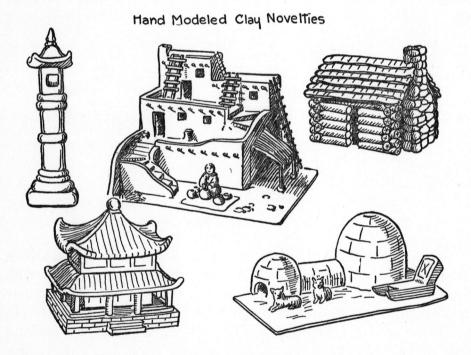

Hand Modeled Clay Novelties

A CHINESE TEMPLE

The base of the Chinese temple is made of a slab of clay and lines are marked on it with a pointed stick or modeling tool to represent rectangular pieces of building stone. The steps in front of the base may be modeled by hand from a single piece of clay or may be made of two

pieces of clay cut with a knife from a rolled-out slab. Moisten the side of the steps that goes against the base with a wet sponge or brush just before you put them in place. Then press them firmly against the base to make them adhere securely.

The rectangular center part of the temple is made with four slabs of clay cut with a knife to the correct shapes and sizes. The clay should be tough enough to handle, yet soft enough to bend easily. When joining the pieces together, wet the adjoining edges of two sides with clay slip. Press the edges together and plaster the inside corner thoroughly with wet clay to make a strong and solid joint. Then dip your fingers in clay slip and rub the outside of the corner. At the same time that you do this, round the corner with your fingers.

The lines that represent rectangular panels on the central part of the temple are made with a pointed stick or modeling tool. They can be drawn either before or after the sides are joined together.

Cut the pieces of clay that form the railing and the uprights to support the roof from a slab of clay. Coat their bottom surfaces with clay slip and put them in position around the base. After the uprights are in place, cut four square strips of clay from a slab, one to rest on top of the uprights in front, one to rest on the rear uprights, and two to go on top of the uprights at each end. These pieces help to support the lower roof.

Make the lower roof with four pieces of clay cut from a slab. Put the pieces in place one at a time, fastening them by coating the parts that contact the central part and the roof supports with clay slip. Use slip also when joining one piece to the next one. Curl up the lower edges of the roof with your fingers, and then draw the lines that represent tiles with a pointed stick or modeling tool.

The upper roof is also made of four pieces cut from a slab of clay. Each piece is triangular in shape, and all four are joined together by coating their edges with slip. The corners are then smoothed, and the lower edges are given their typically Chinese curve, after which lines are drawn in the clay with a pointed tool.

The temple roof is finished off with a ball of clay.

Use whatever colors you wish in painting the temple. The roof would usually be deep red or deep green, but other colors may, of course, be used. The base and central part may be made of terra-cotta colored clay and left unpainted, or may be colored blue, ochre, burnt sienna or some other color. The only principle to follow is to make the temple as attractive and Oriental looking as possible.

A TEMPLE LANTERN

The pillar-like Chinese temple lantern is modeled almost entirely by hand. The only exception is the square base which, if you wish, you can cut from a clay slab.

Roll out a cylinder of clay for the part of the lantern that rests directly on the base and model it by hand into the shape shown in the drawing. When it is finished, coat its bottom surface with slip and put it in position on top of the base.

A thin square piece of clay rests on top of the cylindrical part, and on this piece there is a cube of clay which represents the lantern. There is a square indentation in the center of each side of the cube. These represent the openings through which the light of the lantern gleams.

The pointed top with its curved brim is modeled from a small ball of clay. Put the ball on your table and flatten its base. Then work the brim into shape and taper the upper part of the ball to a conical shape. Finish off the top by adding a spike-shaped piece of clay, as shown in the drawing.

The lantern may be painted red, green, blue or yellow or may be a natural terra-cotta color. Indicate the presence of a lighted lantern by painting the square indentations in the sides of the cube, red, yellow or orange.

AN ESKIMO IGLOO

The Eskimo igloo rests on a rectangular piece of clay rolled out to a thickness of about ⅛ of an inch. Use one of the gray clays. This can later be painted either partly or entirely white. The same kind of clay should be used for the igloo.

It is easiest to make the main dome-shaped part of the igloo from a solid ball of clay. If you prefer, however, you can make it from a rolled-out slab of clay so it will be hollow. After the clay has been rolled out, shape it over a tea cup or a wooden ball, gradually smoothing it into the semi-spherical shape you require. Model it to its final shape after removing it from the cup or ball, and with a pointed tool make the lines that represent the divisions between the blocks of snow of which the igloo is made.

The small dome-shaped entrance and the low tunnel that connects

it to the main part of the igloo are modeled by hand and present no particular difficulties. You can make the entrance igloo from a small ball of clay, and the tunnel can be made most simply by curving a flat piece of rolled-out clay to the proper shape.

Be sure to coat the edges of the three parts of the igloo with clay slip before joining them together. This will insure firm and lasting adhesion.

The sledge is easy to make. Roll out a slab of the proper thickness to form the base and the back, and bend the back to a slanting position. Cut the runners from a thin clay slab and fasten them to the base by means of generously applied clay slip.

Model the dogs by hand, marking in the eyes, nose and mouth with a pointed tool. Use the same tool to roughen the surface of the clay in order to represent the texture of their hairy coats.

When the model is completed, the igloo and the base should be painted a bluish white to represent the color of snow. The sledge can be painted brown, and the dogs can also be painted brown or be given patches of brown against the background color of gray clay.

A LOG CABIN

The lower part of the log cabin is built up with miniature "logs" of clay, in exactly the same way that a real cabin is constructed. The first thing to do is to roll out some ropes or coils of clay about ½ inch thick. Then cut these pieces into the lengths required for the logs in the sides and ends of the cabin.

It is a good plan to draw a floor plan of the cabin on a piece of paper and to use it as a guide to the proper measurements. A good size for a small cabin is 6 inches long and 4 inches wide. The logs that form the back of the cabin would be 6 inches in length, and the log that runs across the top of the cabin's front side, forming the top of the doorway would be the same length. You will need seven of these logs, six for the back and one for the front. Each of the logs intended for the front should be 2½ inches long. This provides for a doorway 1 inch wide. You will need ten of these. In addition, you will need twelve logs, each 4 inches long, for the two ends of the cabin.

When all the logs are ready, build the cabin from the ground up. First put down the bottom log of the rear wall and the two bottom logs of the front wall. Indent each of these near the end with your finger or

a pencil to receive the end logs that rest on top of them. Then make similar indentations on two of the end logs and put them in position. Continue building in the same way until the bottom part of the cabin is completed.

The next step is to build up the triangular parts at each end of the cabin that help support the roof. Do this by putting logs on top of each other, each one sufficiently shorter than the one beneath, to give the required triangular shape.

Make the roof of strips of clay that have rounded edges. After the strips have been put in place, mark them with lines such as those shown in the drawing, using a sharp pointed tool.

The cabin is completed by adding the chimney, which is made of a number of small pieces of clay, each of which is modeled to look like a piece of field stone.

When the cabin is finished, paint the side and end walls and the roof brown. If you use a gray clay for the chimney, it can be left in its natural color, which closely resembles that of stones.

AN INDIAN PUEBLO

The Indian pueblo illustrated on page 45, is fun to make and will be a particularly interesting addition to your collection of clay novelties. Built of gray or ochre-colored clay and completed with the wooden ladders, pile of firewood, the Indian woman making miniature pots, and the other details shown in the drawing, it is a real bit of the old Southwest that will attract attention wherever it is shown.

The pueblo is built on a thin clay base that may be 12 or 15 inches long and 8 or 10 inches wide. Roll this slab out and on it build up the base of the pueblo itself. It is best to make this base of solid clay, and it should be a plain rectangle or oblong in shape. The sloping ramp that leads up to the top story is added later, after the first story has been put in place.

The first story is also a plain rectangle, and may be made of solid clay hollowed out inside with the door and windows painted in black, or it may be built up with slabs. It is easier to use solid clay and this method is recommended for your first model. Hollow out the inside and, if you are using clay that is to be fired, make the walls as thin as possible to minimize the possibility of air holes causing explosions during the firing.

Notice that the front wall projects a short distance above the roof to form a rail, and that the same is true of the left-hand wall. It is best to make this rail an integral part of the rectangle, although it can be added afterwards, if you prefer.

Fasten the first story to the base by using clay slip as an adhesive. When it is in position, build up the ramp that leads to its roof from the top of the base. The clay forming the ramp is leveled off at a point a little below the roof of the first story and a triangular clay step is fitted in position at this point. Notice also that the leveled clay must be continued on to the back of the model to form a base for the right-hand end of the top story. When the ramp is completed, add the low sloping rail that runs along its front and side. Coat the lower edge of the rail with slip and smooth over the join between this edge and the base with your fingers, dipped in slip.

The top story is made of solid clay or slabs, the solid clay being the easier for most people. It will also be found easier to make the story in two parts, the one at the left, as seen in the drawing, being higher than the one at the right. Join the two parts together by coating them with clay slip and then conceal the join by putting slip over it. A low rail of clay runs around the top of each part.

The square chimney at the left-hand end of the top story is modeled by hand. Note that the rail around the roof of the first story terminates against the chimney.

When all these parts have been modeled and put in place, you can insert the small pieces of wood that represent the projecting ends of the roof beams. These should be put in position before the clay gets too hard.

Next make the curved slab of clay that projects from the left-hand end of the base. Roll out a rectangular slab and cut the curved piece out with a knife. It is a good idea first to make a paper or cardboard piece of the right size and shape to serve as a guide. Put this on the slab and cut around its edges with a knife.

The steps that lead from the ground to the top of the base are probably most easily made by cutting a slab of the right size and shape for each step. The first four steps are rectangular in shape. Then come two triangular shaped ones, and then two rectangular ones at the top.

Three clay pieces, cut from a slab, enclose the steps. It is best to make paper or cardboard guides to insure getting these the right size and shape. One piece, clearly shown in the drawing, goes against the front side of the steps. A smaller, triangular-shaped piece goes against the inner side

of the bottom steps, and a rectangular piece projects from the base of the pueblo.

The ladders that lead to the roof of the pueblo's top story are made of small pieces of wood glued together, and should be added because of the increased interest that they give to the model.

At the right-hand end of the pueblo is a shelter with a roof made of rounded strips of clay. The roof supports are small pieces of wood mounted in small bases made of clay.

You can model the Indian woman by hand or can use a doll. She is seated on a small reproduction of an Indian rug and is busily occupied in making pottery. These miniature pots are modeled by hand out of small balls of clay and are painted with typical Indian designs. The mortar for grinding corn, which stands near the door of the first story, is also modeled from a small clay ball. The firewood is a pile of small pieces of wood, which can be held together by means of glue.

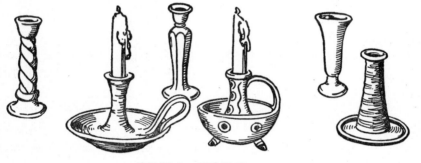

CANDLE STICKS

CANDLESTICKS

Candlesticks may be thrown on the potter's wheel, made by the coil method, modeled or simply shaped up by hand. The latter kind is the easiest for the beginner and very attractive examples can be made by just shaping the clay with the fingers. Fig. 10 *a* shows several candlesticks made in this way.

One of the candlesticks shown has a spiral effect, as though the clay were twisted. This effect is achieved by modeling the clay with a modeling tool, making the spiral lines with the pointed end of the tool. The

candlesticks shown are hand shaped rather than hand drawn, each one calling for an individual method of making. The bases that resemble shallow bowls are made by the hand drawn method from balls of clay. The upright shafts are first rolled out into cylindrical form and then modeled by hand to their finished shape.

HAND-DRAWN POTS

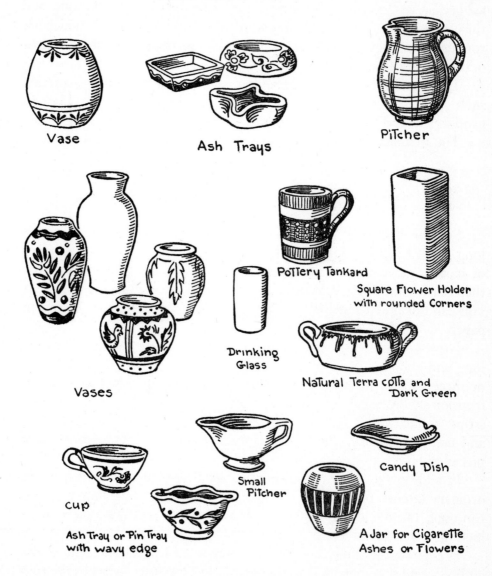

Vase

Ash Trays

Pitcher

Vases

Drinking Glass

Pottery Tankard

Square Flower Holder with rounded Corners

Natural Terra cotta and Dark Green

Cup

Ash Tray or Pin Tray with wavy edge

Small Pitcher

Candy Dish

A Jar for Cigarette Ashes or Flowers

5

Slab Pots

Slab pots are those which have flat sides and are made by putting together or "sticking up" several flat slabs—one for the bottom, and the others for the sides. Differing from other types of pottery, which are rounded, slab pots are usually square, oblong, triangular, hexagonal or octagonal in shape.

This method is used to make all kinds of attractive and useful articles, such as ash trays, boxes, trays, flower boxes and flower pots, bowls, candlesticks and vases. Some typical articles are shown in the illustration.

The first step in making a slab pot is:

ROLLING OUT A SLAB

For this you must get a wooden board measuring about 18 inches long and 12 inches wide. To the top surface of this board tack a piece of closely woven cotton cloth, using four tacks, one at each corner of the board. The cloth is to keep the clay from sticking to the board. If you can not find a suitable piece of cloth, you can use brown wrapping paper.

Now you must get two strips of wood, each measuring 18 inches long and about ¾ inch wide. These are to be nailed lightly with two or three nails to the sides of the board, and their height or vertical dimension should equal the thickness of the slabs you are going to roll. Use strips ¼ inch thick for making most small and medium-sized articles, and use ⅜-inch or ½-inch strips for thicker slabs to be used in large pieces of pottery.

In addition to your rolling board, just described, you will need an ordinary kitchen rolling pin. If you can not get a regular rolling pin, you can use a 14-inch length cut from a broom handle or from a piece of 2-inch diameter dowel wood.

Wedge or knead the clay you are going to use, in order to remove the air holes, and then press it onto the board. Fill the space between the two

wooden strips so that the solid mass of clay projects a little above the tops of the strips. Press the clay down firmly, since the object is to get a thoroughly firm mass throughout.

The clay should be soft, or in what has been described the "moist hard" condition, with no moisture on the surface. When it has been pressed into place, roll it with your rolling pin, continuing until the pin rolls back and forth on the tops of the two wooden strips.

When a slab has been rolled out in this way, it is removed from the board. First separate it from the two wooden side-strips by running a knife between the clay and the strips. Remove the strips by pulling out the nails holding them in place, and then draw the tacks holding the cloth. Let the slab rest on your work table on top of the cloth.

MAKING SLAB POTS

The first step in making a slab pot is to make a careful full-size drawing of the finished pot. Then cut from paper or cardboard pieces, patterns of the same size and shape as each surface of the pot. For a rectangular box, for example, you would need one piece for the bottom, one piece for the two sides and one piece for the two ends. Note that in slab pots the bottom piece of clay should always fit *inside* the slabs that form the sides, not underneath these slabs.

Now place the cut-out pieces of paper or cardboard on the clay slab one at a time and cut out pieces of clay of corresponding shapes by running a knife around the edges of the paper or cardboard pieces. Cut right through the clay down to the cloth or paper on which it rests.

The knife should be held upright and, as a rule, it is a good plan to draw it a little beyond each corner of the pattern so the corner angles will be clean cut. The knife should move easily through the clay. If it sticks at all, the clay is too soft and should be allowed to dry a little more.

When the different pieces have been cut out, you are ready to join them together. First join two of the side pieces to each other. To do this, roughen the edges that are to be joined by checking or small cutting, apply clay slip, press the edges together and finish off the join by cementing the inside of the corner with wet clay.

Fasten the two sides to the base, using clay slip and wet clay, as above, to make all secure. Then join two more sides together, fasten

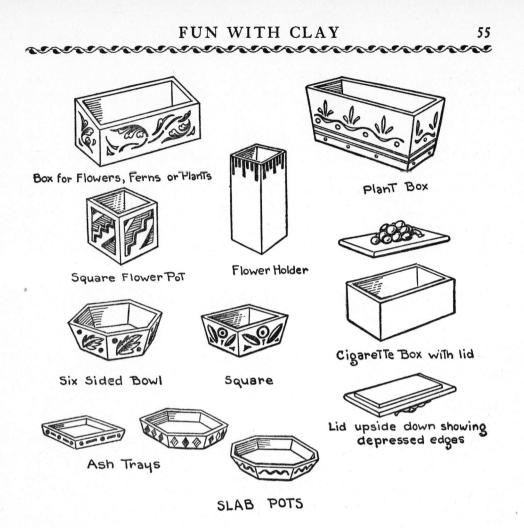

Box for Flowers, Ferns or Plants

Plant Box

Square Flower Pot

Flower Holder

Six Sided Bowl

Square

Cigarette Box with lid

Lid upside down showing depressed edges

Ash Trays

SLAB POTS

them to the base and to an edge of the sides already in position, and continue in the same manner until all the pieces are in place.

A common practice, used to give added strength, is to put a thin coil of clay on the inside of all joined edges. If you have made a rectangular slab pot, one coil would run continuously from the top of the front side at one end to the bottom, then across the bottom join of that end, and up to the top of the rear side. This would be repeated at the other end, and two additional coils would run along the join at the bottom of the front and rear sides.

Finish off by strengthening all the outside corners by dipping your fingers in clay slip and rubbing the outside of each corner. The outside angles should not be too sharp, and any sharpness should be rounded off by smoothing with your fingers or a damp sponge. Rounded corners are

generally considered more suitable for pottery work and, in addition, sharp angles in clay prevent the glaze from adhering in the firing, when this process is to be used.

When the clay has dried until it is leather-hard, smooth the surface by rubbing with your hand or with sandpaper. The finished pot can then be decorated in any way that you wish.

Many slab pots, as well as other kinds, are attractively decorated by means of an incised design, such as the one on the holder for flowers or ferns shown on page 55. These designs are easy to make by depressing the clay with a modeling tool. As already pointed out, incised or relief designs should be made before the sides and ends of the box are joined to the bottom. Other articles may have painted designs or may be colored all over a warm blue, green, yellow, red or some other color.

MAKING A SIMPLE BOX COVER

To make a lid or cover for a box, such as the rectangular cigarette box shown on page 55, cut a slab of clay of the right size and shape, that is, with the outside dimensions of the box itself. Then take a ruler and press down around the sides and ends of the underside of the cover. Make the pressed down parts a little wider than the thickness of the box's walls. This operation will make the central area of the cover's underside a raised surface that will keep the cover from sliding off.

6

Cast and Pressed Pottery Ware

A great deal of pottery is made by using plaster-of-paris molds into which slip or liquid clay is poured and allowed to harden. This is known as "slip casting." Articles that are commonly made in this way include bowls, jugs, flowerpots, candlesticks, pitchers, teapots, vases, lamp bases, and human and animal figures. When you use a mold, you can make a large number of any particular piece, for the mold can be used over and over again.

Molds are also used to make pottery by the method known as "pressing" or "pressing with slabs." Generally, this method is used to make a piece of ware that is too large to be slip cast. It consists of cutting out flat slabs of clay and pressing them into the mold, which gives them the form of the finished piece.

A SIZE IS USED TO KEEP PLASTER FROM STICKING

When making plaster-of-paris molds, you will need a size of some kind to keep the plaster from sticking to containers into which it is poured and to keep the two halves of a mold from sticking together when the mold is being made. These uses of a size are referred to in the following pages and it is necessary to explain at this point, therefore, how you can make or obtain a good sizing material.

A size is also, as a rule, applied to the pattern or model that is used in making a mold. If the pattern is made of unbaked clay, however, a size should not be used, since the liquid size will soften the clay.

Sizes or similar preparations, usually called "separators," are sold by most pottery supply dealers. Their function is to make the surface of the object to which they are applied non-absorbent. There are other easily obtained substances that will do this and you can use one of them if necessary. These materials include shellac, waterglass and linseed oil.

A good home-made size is made with castile soap or, if this is not

obtainable, any other good quality soap. Pour a quart of cold water into a saucepan and shave off the soap in small, thin pieces into the water. Let the mixture simmer on a stove until the soap is thoroughly dissolved. Then pour in ¼ pint of paraffin oil and stir thoroughly.

The mixture is allowed to cool and, when cool, should have the consistency of corn syrup.

Size is applied with a paint brush and, for plaster, three or four coats are usually needed. After the first coat has been applied, wipe the surface with a damp sponge. Treat the second coat the same way. After applying the third coat, the surface will usually repel water as though it were coated with grease. This is the condition you want. If three coats are not enough, apply a fourth. Then, wipe the surface with a sponge that has been dipped, not in water, but in the size itself.

While the use of a well-mixed size is usually recommended, the emphasis in this book is placed on simplicity and for that reason it should be stated that many experienced potters use plain soap applied with a wet brush. For most purposes, this will be found sufficient to prevent undue sticking.

MOLDS

You can make your own molds without difficulty or, if you prefer, you can buy molds for making dozens of different articles from pottery supply dealers. If you make your own you will have to know how to mix plaster and, while instructions are usually furnished with the plaster when you buy it, directions for mixing are given here in case they are needed.

HOW TO MIX AND POUR PLASTER

The plaster used for making molds is plaster-of-paris, which is suited for this purpose both because it solidifies well and because it absorbs moisture from wet clay placed in contact with it. Plaster-of-paris should be kept in an airtight container to keep it from absorbing moisture from the air and losing its ability to set firmly.

To get the proper consistency needed for molds, plaster-of-paris and water should be mixed in the proportions of 1 quart of water to each 2¾ pounds of plaster. This combination provides a mixture that, when the plaster sets, will fill approximately 80 cubic inches.

Before mixing, calculate fairly closely how many cubic inches will be needed to fill your mold. This will enable you to mix approximately the required amount.

The first step in mixing is to put the water in an earthenware jar or bowl or a tin container of the right size. The large containers used for crackers are good for this purpose. Sprinkle the plaster slowly into the water, allowing it to sift through the fingers so no lumps will get into the water. At the same time, use your free hand to stir the mixture to give it a smooth, even consistency.

When the plaster begins to appear on the surface of the water, it is an indication that enough plaster has been poured in. Continue stirring and, as soon as the plaster forms a coating on your hand that you cannot shake off, it is ready to be poured into the mold. Do not delay, for plaster sets quickly and should be poured just as soon as it reaches the condition described.

USE EXCESS PLASTER TO MAKE WORK BATS

Make it a rule to have on hand a tin container or several tin pie pans that have been coated with size, into which to pour any excess plaster. Never pour such plaster into a sink as it would clog the drain pipes. When the plaster poured into the tin containers has dried, it can be removed because of the size, and the containers can then be used again.

The circular plaster shapes removed from the pie pans may be used as "work bats." These are convenient to use as a base on which to build coiled or hand-drawn pots or to model figures.

As soon as you have finished pouring, wipe the inside of the jar, bowl or tin that contained it with a piece of newspaper. Then wash out this receptacle right away to prevent the plaster from adhering to it. Do not, however, permit the washed-off bits of plaster to go down the drain.

The plaster poured into the mold will set in about ten minutes. Do not remove it from the mold, however, for about four hours, as this length of time is required for it to get really hard.

HOW TO MAKE PLASTER MOLDS

A plaster mold is made by pouring or casting plaster-of-paris around a *pattern* of the article that is to be molded. The pattern may be a piece of finished pottery such as a bowl, vase or statuette, or may be a model of the article made of plaster or green (unfired) clay.

Most molds are made either in one or two pieces.

The simplest to make is:

A ONE-PIECE MOLD

This is used for casting such articles as bowls and simply shaped vases. Put the bowl bottom up on a piece of oilcloth or oiled paper on your work table and place around it a square wooden form or a cardboard or linoleum cylinder, made by gluing together the two ends of a strip of the material used and then tying two pieces of string around it, one near the top and one near the bottom. The cylinder should have a diameter approximately 5 inches greater than the diameter of the pattern, and should be 3 inches higher than the pattern.

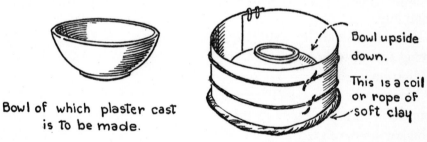

Bowl of which plaster cast is to be made.

Bowl upside down.

This is a coil or rope of soft clay

Make a coil of soft clay and put it around the outside of the bottom of the form or cylinder. This is to keep the plaster from flowing out. Then mix the required amount of plaster and pour it over the bowl. Pour it slowly so no bubbles will form. The plaster will surround the pattern and assume its shape. Wait about thirty minutes for the plaster to harden and then remove the plaster mold from the form or cylinder. Let the mold with the pattern inside it dry for several hours in a warm place, and then separate the mold from the pattern. This can usually be

done by holding the mold upside down and tapping it gently. If the pattern does not come free easily, put the mold under a water tap and run water over it until the moisture penetrates to the clay next to the pattern and loosens the latter.

You now have a mold that is the same size and shape as the outside of the bowl or other article that was used for a pattern. How to cast reproductions of the original pattern is explained later in this chapter under "Slip Casting and Pressing."

HOW TO MAKE A TWO-PIECE MOLD

Two-piece molds are the type most generally used. With them you can make a wide variety of pots and human and animal figures.

The first step is to secure your pattern, that is, the article that you wish to reproduce. It may be a finished piece of pottery ware or a model of the article made of plaster or green (unfired) clay.

With a pencil, draw a line on the side of the pattern to divide it vertically into two equal parts. See 1 in the illustration.

Next put the pattern in a bed of soft clay, until it is even with the pencil line (2). Make the upper surface of the clay level and smooth. Do not let any of the clay get on the part of the pattern that is above the pencil line.

The clay should be even with the mouth or top of the pot that is serving as a pattern, but should extend out about 2 inches from the sides and bottom.

Now make a wooden form of the kind shown in 3 and place it around the clay that contains the pattern. The sides of the form should be high enough to extend 2 inches above the highest point of the pattern.

The corners of the form should be tightly nailed together to prevent the escape of liquid plaster, and its bottom edges should be imbedded in some of the soft clay in which the pattern has been placed. To make doubly sure of the corners, it is a good plan to line them with soft clay.

When the wooden form is in place, mix the required amount of plaster and pour it into the form, filling it to the top.

Let the plaster dry for about thirty minutes or until it is hard and then remove the wooden form. If it does not come free easily, draw out the nails at the corners and remove each piece separately. You will now

How To Make a Two-Pieced Mold

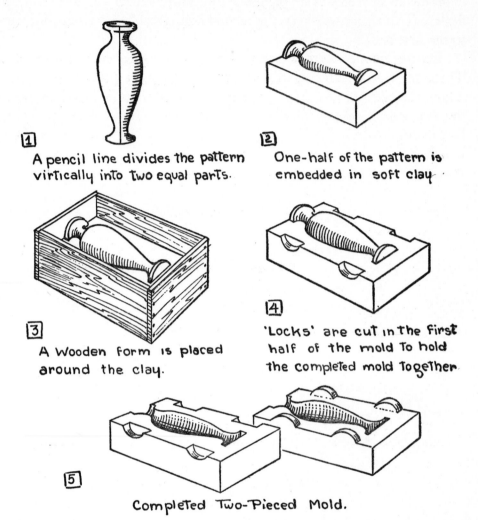

1. A pencil line divides the pattern virtically into two equal parts.

2. One-half of the pattern is embedded in soft clay

3. A wooden form is placed around the clay.

4. 'Locks' are cut in the first half of the mold to hold the completed mold together.

5. Completed Two-Pieced Mold.

have a rectangular form, the lower half consisting of soft clay and the upper half of hard plaster, with the pattern imbedded in the center.

Turn this form over so the plaster half is on the bottom and the soft clay on top. Then carefully remove all the soft clay, and wipe the exposed part of the pattern with a damp sponge or cloth.

With a knife, make "locks" in the plaster to hold the two halves of the completed mold together. A type of lock that is commonly used is shown in 4.

The first half of the mold is now completed and you are ready to make the second half.

First size the upper surface of the first half of the mold, either a home-made soap size or a "separator" purchased from a pottery supply dealer. This sizing will keep the second half of the mold from adhering to the first half.

Put the wooden form, already used, around the first half of the mold. Then mix a new batch of plaster and fill the form with it, as before. Allow the plaster to harden, then remove the wooden form and separate the two halves of the mold by putting a knife blade between them. Remove the pattern, and you will have a completed two-piece mold in which you can cast any number of reproductions of the vase or other article used as a pattern (5).

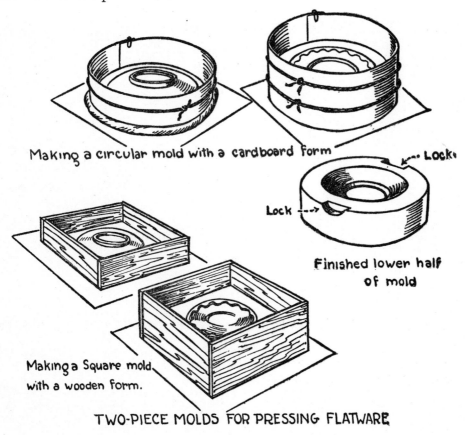

Making a circular mold with a cardboard form

Lock
Lock

Finished lower half of mold

Making a Square mold with a wooden form.

TWO-PIECE MOLDS FOR PRESSING FLATWARE

TWO-PIECE MOLDS FOR FLATWARE

The illustration above shows how to make a two-piece mold for *pressing* flatware such as dishes and plates.

The form into which the plaster is poured may be made of cardboard, as illustrated, or may be a rectangular wooden form.

Put the dish or plate that is to serve as the pattern on your table bottom up, as in making a one-piece mold. Put the cardboard or wooden form around it, making the form with a diameter approximately 5 inches greater than the diameter of the pattern, and a height 3 inches greater than that of the pattern.

Put a coil of soft clay around the outside of the bottom of the form to keep the plaster from escaping. Then mix the plaster and fill the form with it.

This will give you a mold that conforms to the bottom of the pattern. After the plaster has hardened, remove the form and separate the pattern from it by holding the mold upside down and tapping it. Then cut two locks in the upper surface of the mold's sides.

You are now ready to make the upper half of the mold.

Put the pattern back in the recess in the lower half and place a form around the lower half as shown in the illustration. This form must be higher than the one used before, and should extend 3 inches above the top of the lower half of the mold.

When the form is in place, mix the needed amount of plaster and fill the form with it. Allow the plaster to dry, and then remove the form, separate the two halves of the mold and take out the pattern.

How to press dishes and plates with this type of mold is described later in this chapter under "Slip Casting and Pressing."

TWO-PIECE MOLDS FOR CASTING FIGURES

A very large number of figures, such as those shown in the illustration opposite, can be cast in two-piece molds that are made in the identical manner already described under the heading "How To Make a Two-Piece Mold." The procedure is exactly the same as if you were making a mold to cast a vase. Draw a pencil line to divide the figure into two equal parts, then embed it in soft clay and continue in the same way that has already been described.

Figures for casting in a two-piece mold should be fairly simple in design, and should not have too many small details. You can get many such figures to use as patterns at ten-cent stores and numerous others are obtainable at art supply dealers. Many people already have in their

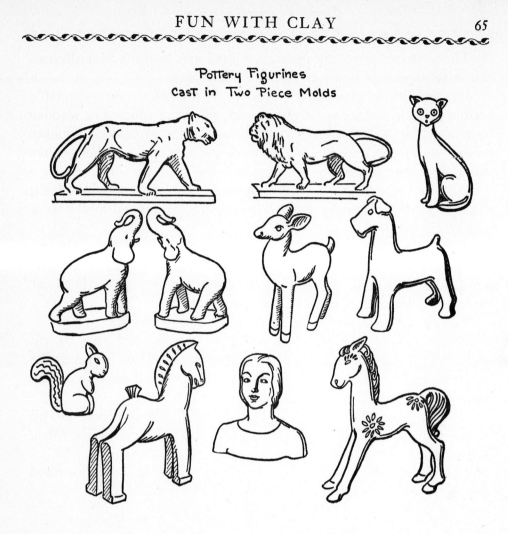

Pottery Figurines
Cast in Two Piece Molds

homes small or medium sized human and animal figures that will make good patterns and be fun to reproduce. When well made and attractively colored and finished, these reproductions may find a ready sale in the shops in your city or town.

FLEXIBLE MOLDS

Flexible molds, usually made of rubber, gelatine or molding jelly, are widely used for modeled pieces such as animal figures. These figures frequently have projecting or curved parts, technically known as "returns," which would prevent the removal of a rigid plaster mold.

Pieces cast in flexible molds are made of plaster-of-paris or of special

Pieces made with Flexible Molds

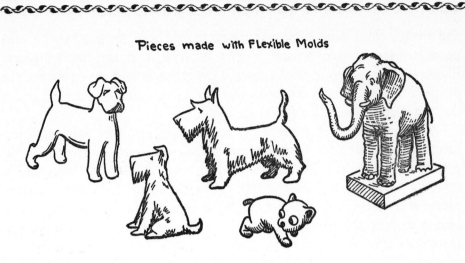

materials prepared by pottery supply houses. They cannot be made of clay because the materials used in the molds will not absorb the water in the clay slip.

Molding jelly and specially prepared liquid rubber, both of which are obtainable from pottery supply dealers, are the best materials for the beginner to use for flexible molds. Gelatine molds shrink quite rapidly after they are made and consequently can be used only for one or two casts, although the gelatine can be melted and made into successive molds. Molding jelly also shrinks, but more slowly, and can generally be used for fifty or more casts. The jelly is then melted and used again. Rubber molds do not shrink and can be used to make hundreds of castings.

A rubber mold is made by applying several coats of liquid rubber and an outside coat of treated rubber in the form of a paste to the pattern —the object that is to be reproduced. This is usually a statuette, or a human or animal figure, but ornamental candlesticks and other articles of a similar nature are also cast in flexible molds.

The pattern is placed in its natural position on the work table and the liquid rubber is applied with a brush that has been dipped in soap-suds to keep the rubber from adhering to it. Usually three coats of liquid rubber are applied to small objects, and five or six coats to larger objects. Treated rubber in paste form is then applied with a spatula to build up the mold.

After the rubber has dried for twenty-four hours, the pattern is removed and the mold is then ready for use. In casting, the inside of the mold is coated with a soap size or a mixture of equal parts of glycerine

and water. The mold is then inverted and held or propped up by supports so that its base, which is open, will be in a horizontal position. Plaster-of-paris, or one of the special casting materials prepared for this purpose, is poured into the mold and after it has dried for several hours, the cast piece is removed from the mold.

When making a flexible mold of molding jelly the pattern is surrounded by a wooden form, whose sides are about 2 inches from the pattern and whose height is 1 inch greater than that of the pattern. The molding jelly, which comes in rectangular blocks, is then cut into small pieces and placed in a tin can, which is put in a pan of boiling water. When the heat has melted the molding jelly, it is poured into the wooden form surrounding the pattern and allowed to harden, thus forming a mold.

SLIP CASTING AND PRESSING

Slip casting is a very simple process, and one that is widely used by the pottery industry for making vases and other types of pots.

A two-piece plaster mold is needed for slip casting and, as has already been mentioned this can be purchased or can be made by the method described in the first part of this chapter.

The first step is to clean the inside of the mold with a damp sponge and when this has been done, the two halves of the mold are fitted together and fastened securely with strong twine, thick rubber bands or wire.

Next prepare the needed quantity of clay slip. This should have about the consistency of thick cream. With most clays the slip will have the right consistency when a pint of it weighs about twenty-six ounces. For pouring the slip into the mold, use a kitchen saucepan, choosing a pan that will hold enough slip to fill the mold at a single pouring.

Pour the slip slowly and steadily into the opening in the top of the mold until the mold is completely full and a small mound of slip rises above the mold. As the water in the slip is drawn into the absorbent plaster of the mold, this mound will disappear, and more slip must be poured in so as to keep the mold constantly full.

As the mold absorbs water, the partially dried slip forms a layer of clay on the inside of the mold. This layer steadily increases in thickness and by tilting the mold and scraping the edge of the layer with a knife,

you can check on the thickness. The correct thickness is largely a matter of choice, but is determined to a large extent by the size of the piece that you are making. Usually about ten minutes are required to form a layer of clay ¼ inch thick inside the mold.

When the clay is the thickness that you want it to be, turn the mold carefully upside down and pour out the remaining excess slip. Tap the mold gently with the palm of your hand to make sure that all the excess slip runs out. Then scrape away the extra clay around the mouth of the mold.

Leave the mold inverted and place it on a rack or on two parallel sticks to drain. Let the clay dry inside the mold for twenty-four hours. Then open the mold carefully and remove the piece that you have cast. It is complete except for finishing, which is described farther on in this chapter.

Human and animal figures are cast in exactly the same way as vases, jars, and other types of pots.

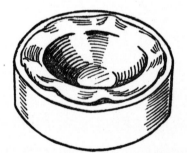

Pressing a Bowl in a One-Piece Mold

PRESSING A BOWL IN A ONE-PIECE MOLD

The illustration above shows how a bowl is pressed in a one-piece mold.

Moisten the inside of the mold with a sponge, and then dust it with talcum powder to keep the clay from sticking to it. Take a lump of well wedged clay, roll it into the shape of a disk, and place it in the mold. Then, by pressing the clay gently but firmly against the sides of the mold, you will give it the shape of the original pattern. It is a good plan to do the pressing with a small damp sponge.

Trim off the excess clay around the top of the mold with a knife and let the clay dry for several hours. The piece may then be removed and allowed to dry thoroughly, after which it is finished.

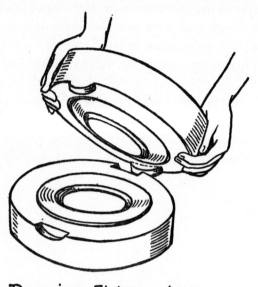

Pressing Flatware in a
Two-piece Mold.

PRESSING FLATWARE IN A TWO-PIECE MOLD

Take a ball of well wedged clay and roll it out into a slab slightly thicker and larger than the piece that you are going to make. Place the slab in the lower half of the mold and pat it with a damp sponge, moving the sponge from the center out to the sides. This is to remove air bubbles.

With a knife trim off the excess clay so the circular slap of clay will have the same diameter as the finished plate. This diameter is, of course, indicated by the mold.

Put the upper half of the mold in place, with the locks engaging those in the lower half, and press down firmly. After the clay has dried for several hours, take off the upper half of the mold and remove the dish.

Put the piece aside to dry and, as the edge will usually dry faster than the center, wet the edge with a damp sponge from time to time. After the piece has dried thoroughly, round the edge with fine sandpaper.

FINISHING CAST AND PRESSED PIECES

As soon as a cast piece has dried sufficiently to handle, it should be finished. The operations involved are all very simple.

First trim off any excess clay around the top of the piece with a knife, then moisten the rim of the mouth and round it with your fingers.

Down each side of the piece there will be a raised mold mark at the point where the two halves of the mold met. Scrape off these marks with a knife. If there are any small air holes or depressions, fill them up with clay dipped in clay slip, smoothing the spots over with your fingers.

Next put on any handles, spouts or other appendages. Then, if necessary, smooth the surface with very fine sandpaper.

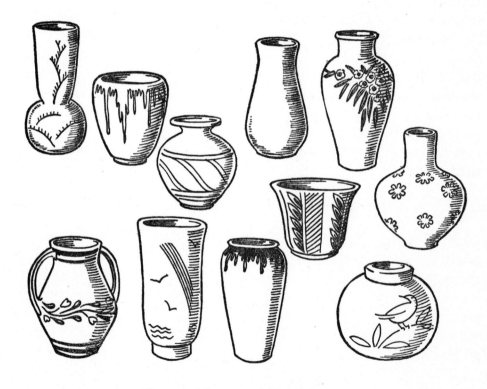

Pottery Made on the Wheel

Many of these could also be made by the Coil or Hand Drawn Method.

7

Throwing on the Potter's Wheel

Making pottery by "throwing" or "spinning" on a potter's wheel is a fascinating type of work and, if your interest in working with clay becomes a real and lasting hobby, you will doubtless want to obtain a wheel of your own. So-called "kick wheels" operated by foot power are not excessively expensive—some cost as little as $40—and can be purchased from the pottery supply houses in your own neighborhood or from those whose names are given in the back of this book. Electrically-operated wheels are more expensive, but somewhat easier to work with.

Essentially, a potter's wheel consists of a circular disk called the "wheel head," which is made to revolve while a pot is being thrown. A ball of clay is placed on the wheel head and, as it revolves, the pot is worked into shape with the hands. With a wheel you can make vases, bowls, plates, ash trays, candlesticks, lamp bases and every other kind of pottery article, except, of course, modeled figures. For throwing, you may use either clay that does not require firing or the types that must be fired.

OTHER EQUIPMENT USED IN THROWING

In addition to the wheel itself, you will need a soft sponge, a basin of water, a piece of broom straw or fine brass wire to check the thickness of the pot's base, and a "rib" or wheel-turning tool which can be purchased inexpensively at any pottery supply dealer's. A rib is a small rectangular piece of metal or wood (sometimes slate or bone) that is used for smoothing and for shaping up a pot, and the turning tool is used for the same purposes.

THE FIRST STEP IS TO MAKE A TEMPLATE

For your first attempt at throwing, choose a simple bowl or vase. Make a full-size drawing of it on a piece of paper and then make a cardboard template as already described and illustrated on page 31.

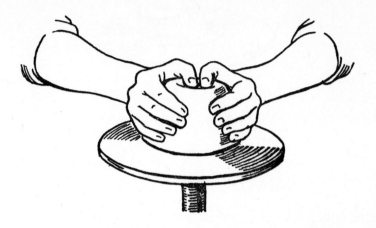

Centering the Clay on the Wheel Head

CENTERING THE CLAY ON THE WHEEL HEAD

After your template is made, wedge a ball of clay as described in Chapter 1. For your first attempts use a clay ball about the size of a tennis ball.

Standing in front of the wheel, throw the ball of clay with considerable force on to the center of the wheel head. Then set the wheel in motion, being sure to make the wheel head revolve in a counter-clockwise direction.

Dip both your hands in a bowl of water provided for the purpose and, as you continue, keep your hands wet so that the clay will revolve without sticking to them.

Now surround the ball of clay with your two hands, placing the thumbs on top. Rest the left forearm on the wall of the trough that surrounds the wheel and keep its rigid. Using the stationary left arm as a guide, press the palms of the hands slowly but firmly against the clay, forcing it true to the center of the wheel head. If necessary, sprinkle a little water on the clay with the right hand.

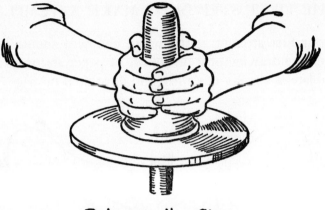

Raising the Clay

MASTERING THE CLAY

The next step is known as mastering the clay. It consists of letting the clay rise into the form of a flat-topped cone and then pressing it down again into the form of a low cylinder. The operation is repeated several times and results in bringing the clay into better working condition for the steps that follow, improving its texture and increasing its strength.

To raise or spin up the clay, press in against its sides firmly but gently. This pressure will make the clay rise and assume the form shown in the illustration. The base will be slightly broader than the upper part. Let your hands rise as the clay rises, but do not pull the clay upwards, for this might pull it off the wheel. When the clay is about the shape shown above, true up the top horizontally with your thumbs.

Next you must lower the clay into the form of a low cylinder. This is done by pressing down on it with your thumbs or the palms of your hands. As it sinks lower and lower, use the thumbs only for pressing down, putting the hands around the clay as shown opposite. Keep your fingers even and exert similar pressure at all points, otherwise one finger might make too deep an impression.

Repeat the process of raising and lowering the clay three or four times, until the mass is smooth and even-textured throughout.

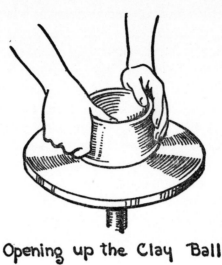

Opening up the Clay Ball

OPENING UP THE CLAY BALL

The next step is to open up the clay ball and spin up the clay into the shape of a cylinder.

Start with the clay in the form of a low cylinder, that is, after you have pressed it down for the last time. With the wheel revolving, place both hands around the clay and press the right thumb slowly down into the center of the cylinder. Continue the downward pressure until the bottom of the cylinder in the center is about ½ inch thick.

You can check this thickness by stopping the wheel and pushing a broom straw or wire through the base of the cylinder to the wheel head. The small hole that is made is filled in, after the wheel is set in motion again, by pressing a finger over it.

The sides of the hole or depression made by the right thumb should have a gradual slope, as shown in the illustration. Do the work slowly until you become accustomed to it, keeping the hands in the positions shown in opening up the clayball, the left hand acting as a guide or mold for the outside, while the right thumb opens up the inside. You will find that the sides of the clay cylinder will rise gradually as the work proceeds.

At this stage the greatest thickness of the clay is near the bottom because the sides slant in toward the center. The next step is to make the side walls of the cylinder of an even thickness from top to bottom.

To do this place the hands around the clay as when first opening the ball, with the right thumb inside. With the wheel revolving slowly, draw the right thumb toward the right fingers, thus pressing the thickest part of the cylinder near the bottom between the thumb and fingers.

This pressure will make the sides of the cylinder rise still more and will make the sides of an even thickness. When the sides are straight up and down, inside and out, true the top horizontally. This is done by putting the left hand over the top edge of the side wall and trueing the edge with the part of the hand between the thumb and the palm.

Now complete the opening up process by inserting a rib or a smooth stick inside the cylinder to level the bottom and square up the part where the side wall joins the bottom. Hold the stick firmly against the side wall, with its lower end resting lightly against the bottom, and revolve the wheel. This will carry out the squaring up process.

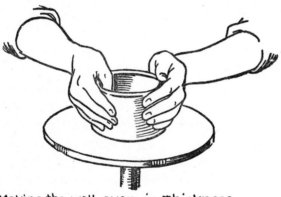

Making the wall even in thickness

KNUCKLING UP

The object of the next step, known as knuckling up, is to give the wall of the cylinder the thickness desired for the finished pot and the height required after it is shaped to its final form. It should be pointed out here that this process is one that requires a considerable amount of practice. Most beginners have to try and try again before they become really proficient. Then, after long and sometimes exasperating effort, they suddenly get the knack of it, and after that there is no difficulty in controlling the clay. To commence "knuckling up," put your left fin-

gers inside the cylinder, pressing the forefinger lightly but firmly against the side. Then place the second joint of your right-hand forefinger against the outside of the pot at a point opposite the left forefinger. Some craftsmen, it may be noted, use a rib on the outside of the pot, instead of the right forefinger.

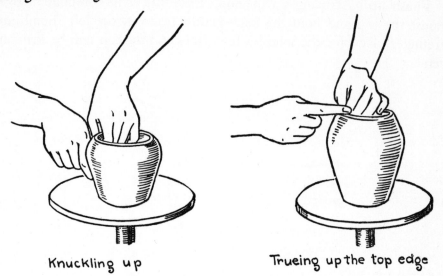

Knuckling up Trueing up the top edge

During the knuckling up process, always keep the fingers inside the pot directly opposite the right forefinger that is on the outside so as to maintain an even pressure at all times against the clay as it revolves between your hands.

Start the wheel and put the tip of your left-hand third finger against the line where the wall of the cylinder joins the bottom. Put your right forefinger opposite and press gently outward with the left-hand finger. This pressure will cause the wall to rise and become thinner.

Now let your two hands rise gradually to the top of the cylinder, keeping the fingers the same distance apart. Be careful not to keep your hands at the bottom too long, thus making the wall at and near the base too thin before the upper part of the wall has been thinned down.

Another point to watch is to synchronize the speed with which you raise your hands with the speed at which the wheel is revolving. Let the pressure of the hands at each level continue until the wheel has completed a full revolution. Otherwise, the pressure of the hands will make a spiral form in the clay, with the spiral thinner than the other parts of the wall, and the entire pot somewhat lop-sided.

Repeat the operation of raising your hands from top to bottom several times, each time making the wall a little thinner. When the walls are the height and thickness that you want, the knuckling up is completed.

The pot will now still be in the form of a cylinder but, as shown in the illustration, the sides may be pressed outward to some extent.

Finish up by trueing up the top. Place the right forefinger lightly against the top and hold the edge gently between the left thumb and forefinger. Revolve the wheel a few times and the top will be firm and even.

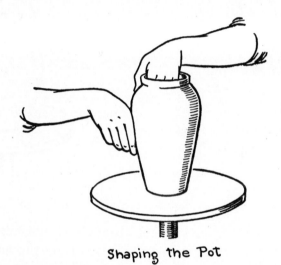

Shaping the Pot

SHAPING THE FINISHED POT

The cylinder is now ready to be shaped into finished form. The shaping is done chiefly with the hands, which are placed in the same position as for knuckling up.

Place the template of the finished pot within easy reach. Then, starting at the bottom and working slowly upward, mold the pot to the desired shape by pressure of the hands.

To make the wall curve outward, press outwards with the left-hand fingers that are inside the pot. When you wish to force the wall inward, press the clay in with your right forefinger. Keep the hands quite stiff or rigid during the operations.

Another method that is used to make an inward curve is to hold the pot lightly between the thumb and two fingers of the right hand. Keep

the left hand around the outside of the pot as a support and slowly draw the thumb and fingers of the right hand together until you have made the desired curve.

Both hands may be used on the outside of the pot to make a long, sloping inward curve. Put the hands one at each side of the pot and press in slowly as the wheel revolves. While the fingers will be principally used, you can also apply pressure with the balls of the thumbs.

The neck and mouth of the pot are shaped by the thumb and fingers of the right or left hand, with the fingers inside and the thumb outside. The illustration shows the left hand in position to shape the neck of the vase above.

FINISHING OPERATIONS

When the pot has been shaped, remove the moisture that has settled inside it with a small, fine sponge, keeping the wheel revolving. If the pot has a narrow neck, fasten the sponge to the end of a stick.

Next smooth the outside of the pot with a sponge. If there are ridges in the clay, they can be removed by holding a wooden or metal rib against the side of the pot as it revolves on the wheel.

The pot may now be removed from the wheel. This is done with the help of a piece of fine wire. Hold an end of the wire in each hand and push it away from you across the surface of the wheel head and beneath the pot. Remove the pot from the wheel with your hands, placing them one on each side of the pot's base.

DRYING

After a pot is removed from the wheel, it must dry sufficiently to permit it to be handled without spoiling its shape. Then it can be touched up and, if required, handles, feet or other appendages may be added.

When the pot is dry enough to be handled, take a damp sponge and with it round off the sharp line that you will see at the edge of the base. At this point you can add handles, knobs or other appendages. Then put the pot aside to dry thoroughly.

Be careful not to place a pot to dry in a spot where there is a draught. This might cause its shape to alter during drying. Select a place where the air is still and the temperature is even. Do not place a damp pot near

heat, for this might cause the clay to crack. Let the pot dry at first at room temperature.

As soon as a pot becomes hard, it can be subjected to heat to complete the drying process. If you are working at home, you can put your pots on a board placed on top of a radiator or over the stove. It is a good idea to bore holes in such a board, for these will permit the warm air to circulate freely around the pots.

Large pots are liable to dry unequally and for this reason you should look at them from time to time as they are drying. If you see that the tops are drying more rapidly than the bases, turn them upside down to make the rate of drying more equal.

All pottery, before it is fired, when it is said to be in a "green" condition, must be handled very carefully. You should always use both hands, for example, when lifting or moving it, except for very small articles. Take care never to lift a "green" pot by a handle, for it will probably come off if you do.

If you are working with a clay that is to be fired, it should dry until it is "white hard" before it is placed in the kiln for the first firing. In the "white hard" state the clay is absolutely dry, with no traces of moisture and, if rubbed or scratched lightly, will come away as a fine powder.

Pots made of clays that do not require firing are allowed to dry thoroughly and are then ready for immediate use.

Modeling Clay Figures

Modeling figures and other objects in clay is an art, similar in all respects to painting or sculpture, but many interesting things can be made with clay without the long training and skill required for success in the other, more difficult arts. This fact is demonstrated by the way in which even very young children make clay models that are excellent and faithful reproductions of natural objects such as fruits, leaves, flowers, vegetables, and even animal and human figures.

Either the self-hardening clays or the regular potter's clays that are hardened by firing can be used for modeling. The finished pieces can be painted or glazed to give them attractive and permanent colors.

If you have never thought of modeling in clay, perhaps considering it too difficult, try it out without hesitation. You will probably find that a little practice goes a long way and that you will soon be able to make many figures and other objects that have a truly professional appearance.

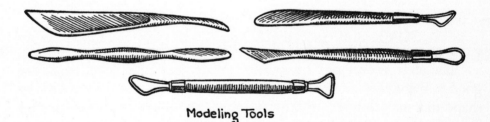

Modeling Tools

MODELING TOOLS

You will need only one or two modeling tools, and these can be purchased at any art or pottery supply dealer. Many people, in fact, use orange-wood sticks such as are used for manicuring, or whittle out their own tools from short sticks of wood. The most commonly used types of modeling tools are shown above. The tool that has wire loops at each end is chiefly used for removing clay during the process of modeling.

The other tools are used for making depressions or incised lines and for smoothing the clay into the form of the finished figure or other object.

Clay for modeling should be almost in the moist-hard state, that is, plastic and easy to shape, but hard enough to hold the shape that you give to it. While working on a modeled figure, keep the clay damp. If the piece is put away between working periods, wrap it in damp cloths and, if practicable, put it in a closed box or put an outer wrapping of oilcloth around the damp cloths.

An important point to remember is that all modeled figures made of clay that is to be fired must be hollowed out before being put in the kiln. In a solid mass of clay, even if it has been carefully wedged, there are likely to be air pockets that might cause an explosion during the firing.

Some figures that are simple in shape can be hollowed out with a knife after they have been modeled. Other figures, such as reclining animals, which rest on a flat base, can be modeled over a core made of damp newspaper, wadded together to form a rough approximation of the finished figure. This core is removed after the clay has stiffened.

In any event, be sure not to fire a piece that has not been hollowed out till the walls are as thin as you can practically make them. If you can not make a hollow figure, use a self-hardening clay that does not have to be fired.

SOME SIMPLE OBJECTS TO BEGIN WITH

The illustration shows a number of easily modeled objects, which are good to begin with in order to get the feel of the clay and learn how to shape and smooth it into the form you want. It is a good plan to start by modeling a few fruits or vegetables, following the illustrations or using a real fruit or vegetable as a model. When these are painted in bright, natural colors they make very attractive gifts that can be used for decorative purposes or as paperweights.

Next try some of the animals, which can be used for the same purposes as the fruits and vegetables. Some people have made collections of a dozen or more different animals, all attractively painted or, if a regular potter's clay is used, painted and glazed.

Skillful coloring of these figures adds immeasurably to their interest, and transforms them from more or less ordinary pieces of modeling into really intriguing decorative objects.

When making any of these relatively simple figures, start by rolling a piece of clay into a ball about the size of the finished figure, or slightly larger, to allow for shrinkage. Then proceed to press or mold it into the approximate shape of the finished figure, taking pieces away and making indentations with a modeling tool, and adding pieces if necessary.

When small pieces or balls of clay have to be added to build up some part of the figure, make certain that the added clay is thoroughly merged into the original mass of clay. As in other kinds of pottery work, pieces added or joined on will adhere better if you scratch the clay with a pointed tool and then moisten the surfaces that are to be joined or coat them lightly with slip. Usually, it is a good plan to keep your finger-ends moist by rubbing them against a damp sponge while you are modeling and adding pieces of clay.

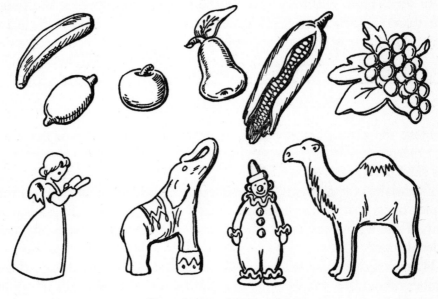

Simple Modeled Objects

After the clay has been modeled to the approximate shape of the finished figure, you must carefully work each part to its correct size and shape. This includes rounding the various parts of the figure, putting in the eyes and other features with a modeling tool or other pointed tool, and incising any lines that are needed to bring out different parts of the figure or indicate body texture. Lines of this type are shown on most of the vegetable and animal figures.

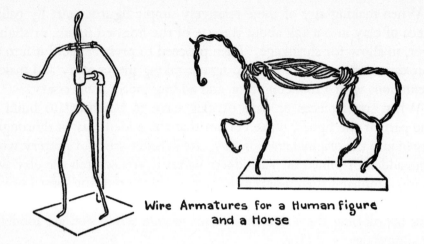

Wire Armatures for a Human Figure
and a Horse

In small figures such as some of the animals illustrated, it is a good plan to strengthen the legs and necks by toothpicks inside the clay. Larger figures are often built around skeleton forms usually made of wire.

MORE ADVANCED FIGURES

Here are some more advanced modeled figures of the type that you can experiment with as soon as you have made some of the simpler figures shown earlier.

Essentially, these pieces are modeled in exactly the same way as the simpler ones, although greater care and experience is required because many of the figures are more complicated and contain a greater amount of detail work.

When a figure has a relatively thin neck and thin arms and legs, these members should be strengthened by toothpicks or other small pieces of wood, or the figure should be built around a wire skeleton or armature of the type shown above. Note, however, that pieces containing wood or wire cannot be fired and should, therefore, be made of self-hardening clays.

If you are using clay that must be hardened by firing, see if you can support any thin extended parts, such as an animal's necks or a human figure's arms, by clay posts or vertical supports. After the clay has hardened sufficiently to stand by itself, the supports are removed and the figure can then be fired.

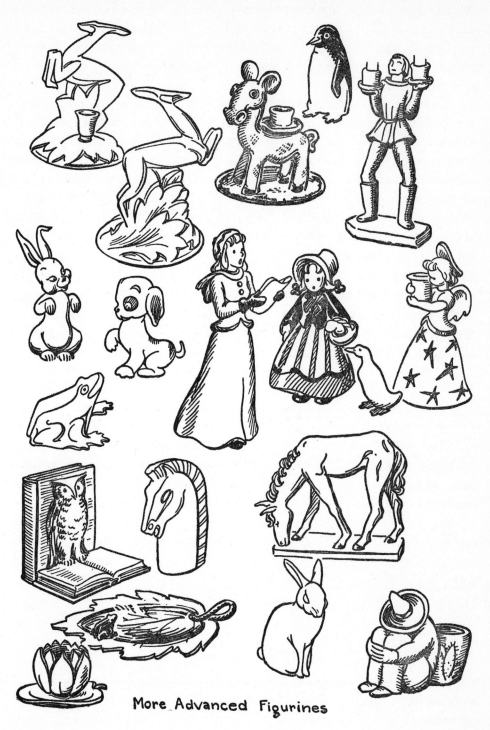

More Advanced Figurines

Candlesticks and bookends are two types of modeled objects that are very popular. They make splendid and useful gifts and, when well done, can usually be sold without difficulty through retail gift and novelty stores. Candlesticks are also thrown on the potter's wheel by experienced craftsmen.

The figures illustrated represent only a few of the practically endless number of amusing and interesting pieces that you can model. If you are creative by nature, you will soon begin to think up figures of your own. Or, as most often happens, you will see figures of all kinds in the homes of your friends and in the stores that you will want to copy or improve upon. Attractively painted, painted and glazed, or finished with an all-over coating of colored glaze, these figures are readily salable, as has been proved by many people. On the other hand, you will enjoy keeping them yourself and giving them to your friends to use for decorative purposes.

If, for any reason, you want to make a number of copies of one of your modeled pieces, you can make a plaster mold of it, as explained in the chapter on "Cast Pottery Ware," and can then make any number of copies of the original figure.

RELIEF MODELING

Clay plaques decorated by means of figures modeled in relief are relatively easy to make and can always be used for wall or other decoration. Heads modeled in relief, which may be true to life or amusing caricatures, are also popular in this kind of work.

You can use regular pottery clay or one of the self-hardening clays for modeling in relief, and the finished pieces can be painted, painted and glazed, or given an all-over coating of colored glaze. Bright colors add a great deal, of course, to the attractiveness of most of the pieces. However, bas relief panels containing human figures, of which several are shown in the illustration opposite are usually executed in white, gray or terra-cotta colored clay and left undecorated.

Fairly stiff clay should be used for modeling in relief and, where the piece is to be square or rectangular in shape, the clay is put in a wooden form of the desired size and shape and is rolled out into a compact slab.

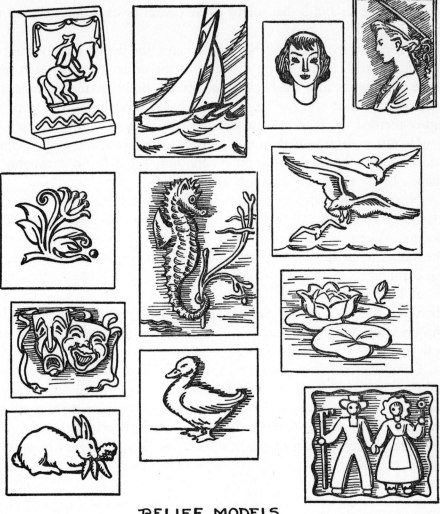

RELIEF MODELS

Draw the outline of the design or figure you are going to model on a piece of tissue paper. Put the paper on the clay slab, and draw a pencil over its lines. Then remove the paper and incise the lines very lightly with the pointed end of a modeling tool.

You now have a good guide on the clay itself, to follow in carrying out the rest of the work. If you are using a regular pottery clay that is to be fired, the design should be brought out into relief by removing the clay that surrounds the design with a modeling tool. That is to say,

no small or large pieces of clay should be added, since they create the possibility of air holes that might cause cracks or explosions during the firing.

When you are using self-hardening clays, the design may be built up by adding small pieces of clay, one after the other, merging each small piece thoroughly into the background piece. Some potters consider this method an easier one for beginners in relief modeling. You may use either method or, with self-hardening clays, a combination of both.

Do not attempt to make a finally modeled figure at this stage. Simply add clay little by little to build up the figure and bring it roughly to shape. Leave the final modeling till later.

Next take a modeling tool or, using your fingers, begin to remove clay where needed and to model the clay more closely to the finished design. Work slowly and carefully now, trying to bring each part of the design to an approximation of its finished shape and height from the background.

A little practice will go a long way toward showing you just how the work is carried out. The principal thing is to get started and follow the general method of modeling that has been outlined here. After a few tries, the whole process will begin to seem a very simple one.

Continue modeling the figure, using your fingers and wherever necessary a modeling tool, until it is finally in its finished form. Use a modeling tool to make needed depressions or lines, such as eyes and other features and the lines marking the folds in clothing.

If the relief is made of clay that is to be fired, it should be allowed to dry very slowly and for a longer period of time than vases and other pots.

9

Decorating and Glazing Pottery Ware

There are seven principal methods that are used for decorating pottery ware such as vases, pitchers and bowls, made of clay that is to be hardened by firing. These are: (1) Incising, (2) Relief, (3) Sgraffito, (4) Slip or Englobe Painting, (5) Simple Glazing, (6) Underglaze Painting, and (7) Overglaze Painting. These are illustrated on page 22 and are described below.

Pottery made of self-hardening clays may be decorated by incising or relief or may be given painted designs or an all-over coating of paint. This type of pottery is frequently finished off and given a glossy appearance by applying a coat of clear varnish after the paint has dried. The appearance is then quite similar to that of glazed pieces.

So-called tempera colors, which are sold by pottery supply dealers and artists' supply stores, are commonly used for decorating pottery. These colors come in powdered form and mix with water quickly and easily to form smooth-flowing, quick-drying and odorless paints. Different colors may be blended, and white tempera is used for making tints or lighter shades. A tempera known as "extending white" is used to increase the volume of a color without changing its working qualities.

The richness and variety of color that can be obtained with these colors is apparent from a brief list of the shades in which tempera colors are available. These include red, red-orange, orange, yellow-orange, yellow, yellow-green, green, blue-green, blue, blue-violet, violet, red-violet, magenta, turquoise, brown, scarlet, dark green, dark red, dark blue, gold ochre, burnt sienna, gray, white and black.

With a palette of this description, it is easy to see how your natural color clay vases, ash trays, candlesticks, tiles and other objects can be quickly transformed into brightly and beautifully decorated finished pieces.

When a vase or other pottery object is being painted, it is frequently placed on a small revolving wheel so it can easily be turned around and

the person who is doing the painting does not have to keep changing his position as the painting progresses. A wooden wheel that can be used for modeling work and for decorating, and that is easy to make at home, is illustrated here.

The base of the wheel is made from a piece of 1 inch thick wood, measuring about 12 inches square. To this is nailed an upright made of a piece of wood about 4 inches square and 3 or 4 inches long. The nails that hold it in place are driven upward through the base. On top of the upright is mounted a circular wooden wheel, the usual diameter being 7 or 8 inches. Drive a large nail through the center of this wheel until it comes out the under side. Take the large nail out and put a smaller nail through the hole. Put the point of the smaller nail into the center of the upright and drive the nail in part way. It should be loose enough so the wheel will turn around on it easily and without friction.

The illustration also shows another method of handling a vase while it is being painted. This very simple device is used by Chinese and other Oriental potters and is employed even for decorating the most exquisite cloisonné ware, famous for its beautifully executed designs and exceptional colors.

The device consists of two wooden sticks nailed together at right angles. The upright stick is then nailed to a small wooden box. This box is placed on your work table so you can stand or sit while you are painting your pottery. The vase to be decorated is supported by the horizontal stick, as shown in the drawing, and the painter holds it steady by putting his left hand against its base.

In most cases the design to be used on the pot is first drawn to scale on a piece of thin paper and is then transferred to the clay. If the clay is still relatively soft, the design is transferred by holding the paper against the pot and going over the lines of the design with a pencil. If the clay is dry or has been given a biscuit firing, draw the outlines of the design with a very soft pencil, place the pencil marks against the pot, and rub the back of the paper with your fingers. This will transfer the outlines of the design to the clay and they can then be made more clear by going over them with a pencil. On dry clay the design can also be transferred by using carbon paper. Pencil lines on the clay, and lines transferred by carbon paper, disappear when the piece is fired.

(1) *Incising*. This was the earliest type of pottery decoration and was a result of the primitive method of making pottery in baskets which

served as molds. The impress of the basket made a rough incised pattern. Later, patterns were scratched in the clay with pieces of wood or bone.

Incising is still widely used today and is the simplest method of pottery decoration, although really beautiful effects can be achieved when well-conceived designs are used.

Incising is done when the clay is almost leather-hard. The outlines of the design are cut in the clay with an incising tool, each line forming a groove about ⅟₁₆ of an inch wide and ⅟₁₆ of an inch deep. Later, when the clay has dried thoroughly, the piece may be glazed, if desired.

Making a Plaque Modeled in Relief

(2) *Relief*. In this method of decoration the design is made to stand out in relief by cutting away the background clay with a modeling tool. If the piece is to be glazed, all sharp edges of the design should be rounded by going over them with a small brush that has been dipped in water. If the edges are left sharp, the glaze may be too thin at these points.

(3) *Sgraffito*. The sgraffito method of decoration consists of covering a vase or other object with a coating of clay slip of a contrasting color to the clay beneath, and then cutting away the slip along the outlines of the design. This permits the different color of the pot to show through. The method is characteristic of much Mexican, Grecian and Indian pottery.

The method originated in districts where red or yellow clay was common, but creamy-white clay was hard to find. The pots were made of red or yellow clay and then dipped in cream colored slip. When the slip was sufficiently dry a design was drawn on it, and the lines of the design were then cut or scratched away to show the red or yellow clay beneath.

To decorate a pot by this method, cover it while the clay is still damp with a fairly thick coat of slip, having a color different from that of the clay in the pot itself. Let the slip harden until you can draw the design on it. Then, before the slip becomes too hard to cut, go along the outlines of the design with a modeling tool, removing the slip where called for by the requirements of the finished design.

Usually, such a piece is given a biscuit firing and is then coated with a clear or transparent glaze and given a glost firing. (See Chapter 10.)

(4) *Slip or Englobe Painting*. A great deal of pottery is decorated by this method, in which the design is painted on the surface of a pot with a brush dipped in colored clay slip. Much peasant pottery is decorated in this way, the old English Toft ware being one example.

Clay slip for this purpose may be colored by mixing it with underglaze colors sold by pottery supply dealers, or clays already colored may be obtained from the same source and mixed with water to form slip.

Make a thick slip and paint the design on the pot while the latter is still damp. The piece is then given a biscuit firing, after which it is coated with a transparent glaze and given a glost firing.

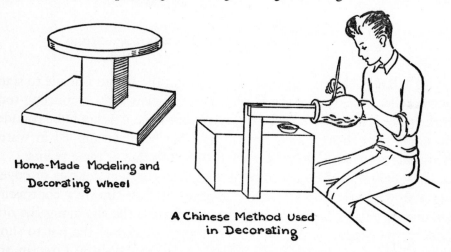

Home-Made Modeling and Decorating Wheel

A Chinese Method Used in Decorating

GLAZING

The glazes used on pottery ware are formed essentially of glass and, when melted during firing, form glassy coatings over the clay. They are applied for decoration and also to make the ware impervious to moisture. They are purchased in powdered form and are mixed with water to prepare them for application.

There are many different kinds of glazes and it is recommended, therefore, that you buy yours from the pottery supply dealer from whom you obtain your clay. The dealer will supply complete instructions for applying the particular glazes purchased, including the heats which should be used for firing, which differ with different types of glazes.

LOW FIRE GLAZES

For beginners, it is recommended that the rather recently developed low fire glazes be used. These mature at above 1607 degrees Fahrenheit, while the average maturing temperature of other glazes is usually over 1900 degrees Fahrenheit. The low fire glazes are less susceptible to cracking and pinholing and have better covering properties than the older high fire glazes. In addition they require less firing time, which results in lower firing costs and slower kiln depreciation.

Glazes are used in three principal ways:

(1) *Simple glazing.* This consists of giving a piece of pottery a coating of transparent or colored glaze. Many lamp bases, vases and other types of pottery ware are given a beautiful all-over coloring by this means. The glaze is applied to the ware after the latter has been given a first, or biscuit firing.

Underglaze Painting

(2) *Underglaze painting.* In this method of decoration, a design is painted on the pottery with special underglaze colors, after the piece has been given a biscuit firing. The piece is then given a light coating of clear, transparent glaze, and is fired again. This second firing is known as glost firing, or the firing of ware to which glaze has been applied.

A piece of pottery decorated in this way will have a painted design which will be covered with a glossy, transparent glaze. The latter pro-

tects the ware against moisture and also gives life and brilliance to the colors used in the design.

(3) *Overglaze painting*. This is sometimes called enamel or china painting and is generally used only for very fine pieces of pottery. The piece is first given a biscuit firing. It is then covered with a coating of clear glaze and given a glost firing. The design is then painted on with special overglaze colors or enamels, after which the colors are hardened on by a third firing at a lower heat than the previous two, usually about 1375 degrees Fahrenheit.

PREPARING AND APPLYING GLAZES

While experienced workers frequently make up their own glazes to suit their own particular needs, there is no necessity for the beginner to go to such lengths. Pottery supply dealers carry in stock hundreds of different prepared glazes in every conceivable color. These come in powdered form and are quickly and easily made ready for use by mixing them with water. Usually, one pound of powdered glaze is mixed with one pint of water.

Before applying the glaze, the ware is given a biscuit firing, after which all dust and dirt should be wiped off. In its biscuit state, prior to glazing, pottery should be kept very clean; for if any grease or dirt gets on it the glaze will not stick. You should be careful, therefore, to keep your hands clean when handling biscuit ware.

Glaze is applied in four ways, which are (1) dipping, (2) pouring, (3) spraying, and (4) brushing.

(1) Dipping is usually used for small or medium-sized pieces. The glaze is placed in a pan, jar or other container and the piece is simply dipped into it and then placed upside down on two parallel sticks laid across the top of the container, so that excess glaze may drain off. When dipping, the piece should be held either by the rim or the base and the thumb and one finger should be used.

(2) To pour glaze to cover the outside of a piece of pottery, put the piece upside down on two parallel sticks laid across the top of a pan or jar. Then put the glaze in a large cup or a saucepan and pour it over the base of the piece, letting it run down until the sides of the piece are covered.

Cups, bowls and some other pieces must be glazed inside as well as

out. This is done by pouring enough glaze into the piece to fill it half full, then tilting and turning the piece until its inside surface is coated. The glaze is then poured out into a container.

(3) For spraying, special sprays can be obtained from pottery supply dealers. The piece to be glazed is placed on a modeling wheel and is made to revolve while the glaze is being sprayed on.

(4) Brushing is very simple and may be used with practically any type of ware. A soft flat brush is used, which is dipped into the glaze, and the ware is given two or three coats of glaze. Care should be taken to make the brush strokes in one direction only.

When the glaze has been applied, touch up any spots on the rim or base where you may have held the piece, with a soft brush dipped in the glaze. Then allow the glaze to dry thoroughly before touching or handling the piece.

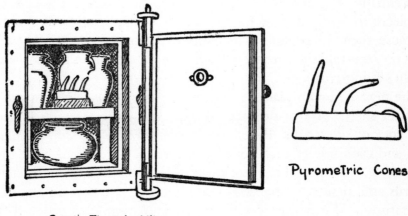

Small Electric Kiln

Pyrometric Cones

10

Firing Pottery

The firing of pottery is usually carried out in two stages, biscuit firing and glost or glaze firing. The first, or biscuit firing, expels the moisture and fuses the clay through contact with great heat, turning the clay into a hard consolidated mass. The second firing, after the glaze has been applied, develops the glaze.

When a piece is decorated with overglaze painting, that is, a design painted on the first coat of glaze, the piece is then fired a third time, at a lower temperature.

Firing is done in special kilns, which may be electric, gas or oil burning. The sizes of their firing chambers range from about 9 inches square to about 20 inches square. They come in many sizes and types and nowadays are quite reasonably priced.

Essentially, the process of firing pottery in a kiln is a simple one. The pieces to be fired must be entirely dry, for the slightest moisture will cause them to explode when subjected to great heat. They are placed on removable shelves which, when filled, are put in position inside the kiln's firing chamber.

The next step is to place several pyrometric cones in a clay slab on one of the shelves so that they can be seen through the peep-hole placed in the door of every kiln. Pyrometric cones have a long, thin pyramidal shape, and each side of each cone has a base that is ½ inch wide and a length of 2½ inches. They are made of various mixtures of ceramic materials and in such proportions that they will soften at different kiln temperatures. When the specific temperature has been reached, the cone that is made to indicate it will bend over slowly, and as you look at it from time to time through the kiln's peep-hole, you can see (1) how far the rate of temperature has advanced and (2) when the pottery has been properly fired. When the cone which indicates the finishing point of the firing bends over so that its tip touches the clay slab in which its base is imbedded, the fire is shut off, and the firing is completed.

The temperature for maturing most clays and glazes is 1900 degrees Fahrenheit. With a small kiln about three hours is required to reach this temperature; with a large kiln about five and three-quarter hours.

To the beginner, the operation of a kiln and the use of the hitherto unheard of pyrometric cones may sound difficult. It is not so at all, however—particularly since, as you start and continue your work with pottery, you will be certain to meet other people interested in the craft and, from talking with them, will soon become familiar with all the new terms, articles and processes that have to do with pottery.

The glost firing is carried out in the same manner as the biscuit firing, except that the floor of the kiln is dusted with finely powdered flint, which is sold for this purpose by pottery supply dealers. The flint serves the purpose of catching any drops of glaze that fall from the pot and also eliminates the possibility of the fired piece attaching itself to the floor of the kiln. Instead of using powdered flint, you may paint the muffle bed of the kiln with flint solution. In each case, you will know from the information supplied by the supply house from which you buy your clays and glazes the temperatures at which these materials mature. All that you have to do then is to use the pyrometric cone that will bend when this temperature is reached, start your kiln going, and shut off the fire when the pyrometric cone bends over. The kiln is then allowed to cool until the pieces can be removed with your bare hands, and the firing operation is then completed in its entirety.

Pottery Supply Dealers

AMERICAN ART CLAY Co., *Indianapolis, Ind.*
 (Marblex and Mexican Pottery self-hardening clays, modeling clay, paints, glazes, wheels, kilns, pyrometric cones, etc.)

B. F. DRAKENFELD AND Co., *45 Park Place, New York*
 (Pottery clays, glazes, kilns, plaster molds, pyrometric cones, wheels, modeling tools, etc.)

DUDLEY STUDIOS, *3211 Temple St., Los Angeles, Calif.*
 (Pottery clays)

FAVOR, RUHL AND Co., *43 West 23rd St., New York*
 (Seramo clay, fired in a kitchen oven)

FELLOWCRAFTERS, INC., *64 Stanhope St., Boston, Mass.*
 (Special pottery clays, including K.O. modeling clay, which can be fired in a kitchen oven; also special casting materials for use in molds, and material for making flexible molds.)

GLADDING MCBEAN & Co., *Los Angeles, Calif.*
 (Pottery clays)

THE KALLIN Co., *7346 Santa Monica Blvd., Los Angeles, Calif.*
 (Pottery clays)

STEWART CLAY Co., INC., *629 East 16 St., New York*
 (Model Light self-hardening clay, pottery and modeling clays, materials for making flexible molds, modeling tools, etc.)

UNITED CLAY MINES CORPORATION, *Trenton, N. J.*
 (Pottery clays)